I dedicate this tribute from my heart to you
solitary wanderers, shaken by the tears of memory,
the lure of unknown havens, and the urgent hungers of the flesh;

And to all tenacious, stubborn dreamers,
kindred spirits, those who refuse to stop believing
in a brighter future.

This is the kiss of a restless photographer
who wants to drown the world in color.

S. G.

Salvo Galano

Sidewalk Stories

Introduction by Jeff Bridges
Afterword by Patrick Markee

pH powerHouse Books
New York, NY

Introduction

In the United States, the wealthiest country on earth, the poor, the hungry and the homeless must live in the shadows. They are nameless, faceless, and literally don't have a place to be in the American Dream. In a society driven by possessions and consumption, the appearance of people in need provokes and threatens.

Sidewalk Stories gives us an opportunity to see the homeless in the brightness of a makeshift studio, apart from our projections of pity, resentment, or fear. Through Salvo Galano's camera and compassion the mysterious homeless who frequent the Holy Apostles Soup Kitchen in New York City are revealed and celebrated. Separated from their life circumstances by a simple photographer's backdrop, their essence, love, and beauty are exposed.

The photographs in this book provide a new vision of the homeless. In a departure from traditional photo essays on homelessness, Salvo doesn't hunt for the "other"—pathos, perversion, or distance. Instead, he discards the distinction between "us and them." His photographs move us to experience the humanity of homeless men and women who exist in a society that unconsciously, but desperately, wants to deny their existence.

As Salvo tells us, the intention behind *Sidewalk Stories* was to be of service. It is his hope that by "putting a face" on the statistics of homelessness, he can help create a context for effective action. As we enter a new millennium, the need for that action is great.

Today, our country must confront the reality that an astonishing number of our people suffer from want. According to the most recent U.S. Census, 32 million Americans (12 million of them children) face hunger. Nearly 12 percent of our population lives in poverty. And best estimates place the number of homeless at 2 million. No other Western industrialized country has such widespread hunger, poverty, and homelessness within its borders.

Across the country, soup kitchens, shelters, and food banks try, but cannot meet the need. Furthermore, it is impossible to expand their capacity to a level that would match the demand for their services. Most people don't realize that their appearance coincided with the decline in effective national social programs.

Today these national programs are under funded, and after years of criticism, have become so punitive that they drive away the people they were intended to serve. Paradoxically, this inability to serve those who qualify for assistance strengthens the argument that we should abandon the idea of national programs for the hungry, poor, and homeless.

How do we begin to address the crisis? Like Salvo, I believe it requires a new vision. In this vision, providing for America's most vulnerable citizens becomes a personal and national priority. But to construct that vision we must first learn how to see the hungry, poor, and homeless as people like ourselves. In the photographs that comprise *Sidewalk Stories*, we are given the cues for this kind of seeing.

Jeff Bridges, April 2001

Homeless but not hopeless

All of the protagonists in this journey are travelers without a home. At a certain point in their lives, by chance or by misfortune, they lost their way, something that could happen to any one of us. Contrary to prevailing negative stereotypes of the homeless, they are not very different from you and me. They have families, strong friendships, love stories, and in spite of their situation, hope and desire for a better life.

I began developing the idea for *Sidewalk Stories* in December, 1996 when I was working as a volunteer at the soup kitchen run by the Church of the Holy Apostles in New York City. I had been concerned with the proliferation of homelessness in New York for several years, and I wanted to learn more about the issue firsthand. I was unprepared for what I discovered.

There are nearly 100,000 people now, the dawn of the third millennium, who experience homelessness every year in New York; families and children comprise nearly three-quarters of that figure. From 1980 to 1995, the number of homeless families and individuals has increased by more than 100 percent, while federal and local support for those in need has not nearly kept pace. Although costs of providing shelters for the homeless is between two and nine times less than the expense of providing the prison cells or psychiatric care facilities where so many of the homeless end up, government organizations are unwilling to take the steps necessary to eliminate this serious social problem.

Living without a home or any kind of support in a continually evolving democratic society is one of the worst experiences a person can endure. I consider the failure of our society to resolve the homeless crisis a major offense to all human beings.

I decided to create a book that would convey these disquieting facts about homelessness, while photographing those who lived under such harrowing circumstances in a humane and dignified manner, one that reflected their true, inner selves. My endeavors were greatly enhanced in 1998, when I received a John Simon Guggenheim Memorial Foundation grant with which I was able to begin the process of taking pictures and gathering information.

Sidewalk Stories is what I learned.

Salvo Galano, January 2001

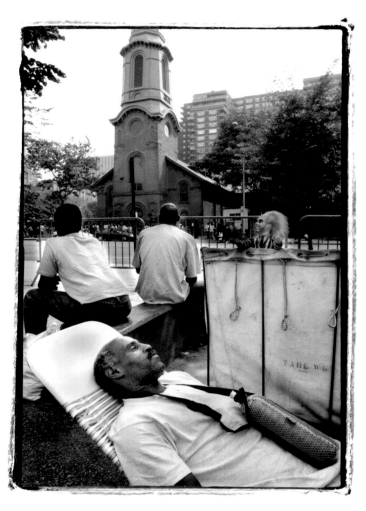

Outside the Holy Apostles Soup Kitchen

The Soup Kitchen

Fortunately there are still people interested in fighting the problem of homelessness, even if there are not nearly enough of them. One of the privately funded organizations in New York City that supports this cause is the Holy Apostles Soup Kitchen.

Started and assisted by the faith-based Church of the Holy Apostles, this soup kitchen has been actively operating since 1982. It's a non-profit organization managed by volunteers and supported mostly by donations. Every weekday, all year long, it provides hot meals, legal advice, medical help, and spiritual support to the needy.

When it was started almost twenty years ago, the Soup Kitchen served twenty-five meals a day. Today, it is the largest soup kitchen in the state of New York, serving an average of 1,100 meals daily.

In the following pages I present the guests of this miraculous place—my own headquarters, like theirs, for almost three years.

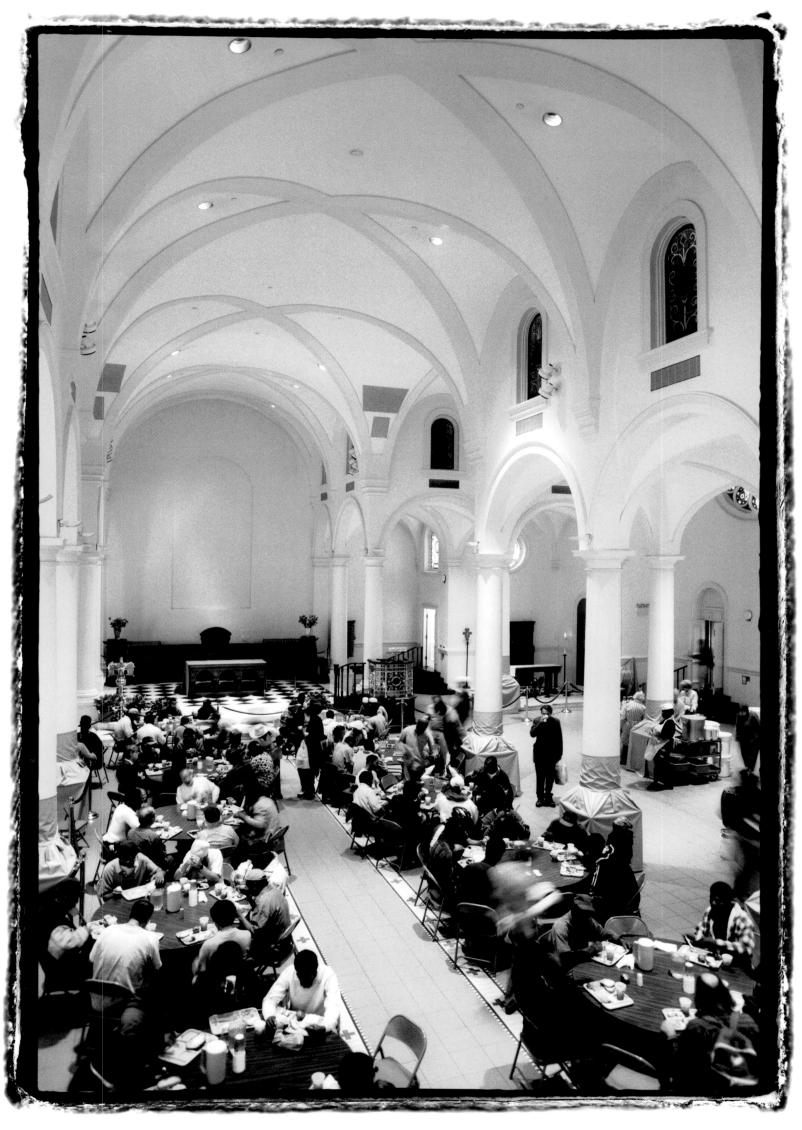

Inside the Soup Kitchen

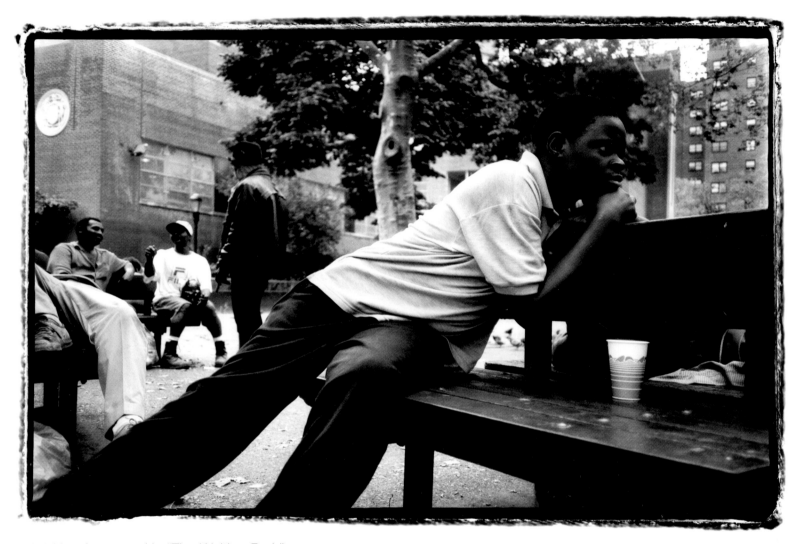

Waiting for a meal in "The Waiting Park"

"The Waiting Park"

Instead of taking a more traditional documentary approach toward the depiction of homelessness, I chose to put together a collection of portraits of the people I met everyday at the Holy Apostles Soup Kitchen. The photographs were taken in a makeshift "studio" outdoors in a park opposite the Kitchen. Here the homeless would gather to wait. For a meal. A friend. A home. A better life.

My "outdoor studio" was a simple burlap cloth nailed to a wall, and served as a backdrop which removed my portrait subjects from their urban surroundings, placing them in a timeless, placeless dimension. Behind the backdrop the city and the pain disappeared; before it, these individuals could simply be men and women, poised with silent and disarming dignity. With this setup, we circumvented the descriptive violence of reportage that too often transforms these subjects into passive protagonists of their own misery. Knowing that these pictures would be displayed in public, my sitters didn't want the viewers to pity them, so they tried their best to "dress up" for the occasion, choosing the nicest clothes and things they had from among their meager personal belongings.

They were just trying to look like human beings, for those who might have forgotten.

My friend, Ronald Rosario B.

It was he who first broke the ice—a sort of guardian angel.

When I first met Ronald, he was sitting on the edge of the sidewalk at the corner of Seventh Avenue and Christopher Street. His friendliness encouraged me to approach him, and with that moment began a long and meaningful friendship that still exists today. With Ronald's help, I learned a set of rules that people living on the street respect and adhere to with conviction, as well as the communication skills necessary to relate to others who are homeless.

Ronald is a man of fifty-seven years, homeless for about forty of those years. His permanent job, as he defines it, is "street entertainer." Using the sidewalks of New York as his stage, Ronald performs little ad hoc street shows. His goals are simple: to make the passersby smile, and to collect a few coins for food, and for cigars and coffee—his only vices, in which he indulges almost constantly. Ronald's parents came from Sicily, and one of his desires is to be able to one day visit this land, which for him has always existed in dreams.

Ronald is the only homeless person I photographed outside of the Soup Kitchen. In making this book, I conceived of him acting as a spokesperson for the general homeless population in New York. He accompanies the statistics that represent their lives, their hardships—our journey. My spiritual guide and ideal "narrator," Ronald shows us that homelessness doesn't necessarily mean hopelessness; that the word "homeless" does not, etymologically speaking, imply any derogatory or negative meaning; and that the story of a homeless person could be the story of anyone.

Without exception.

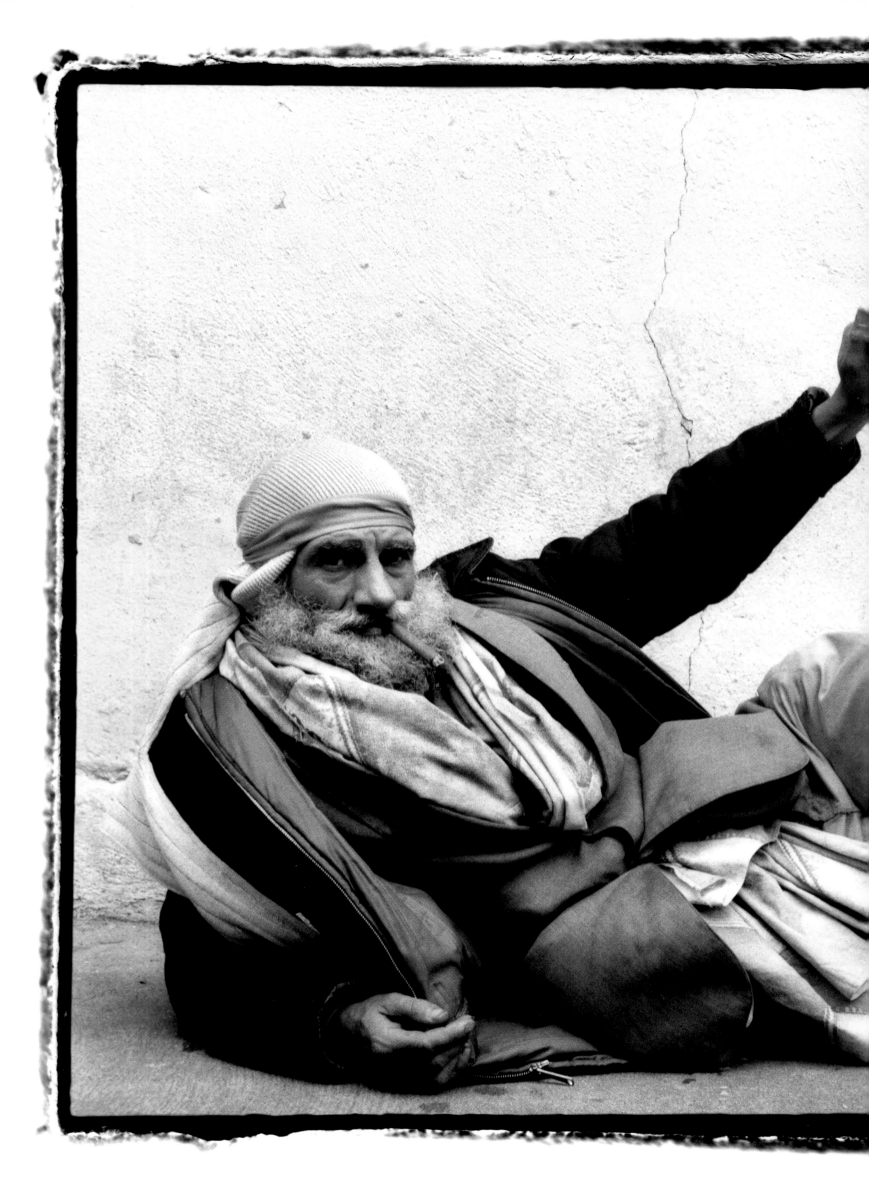

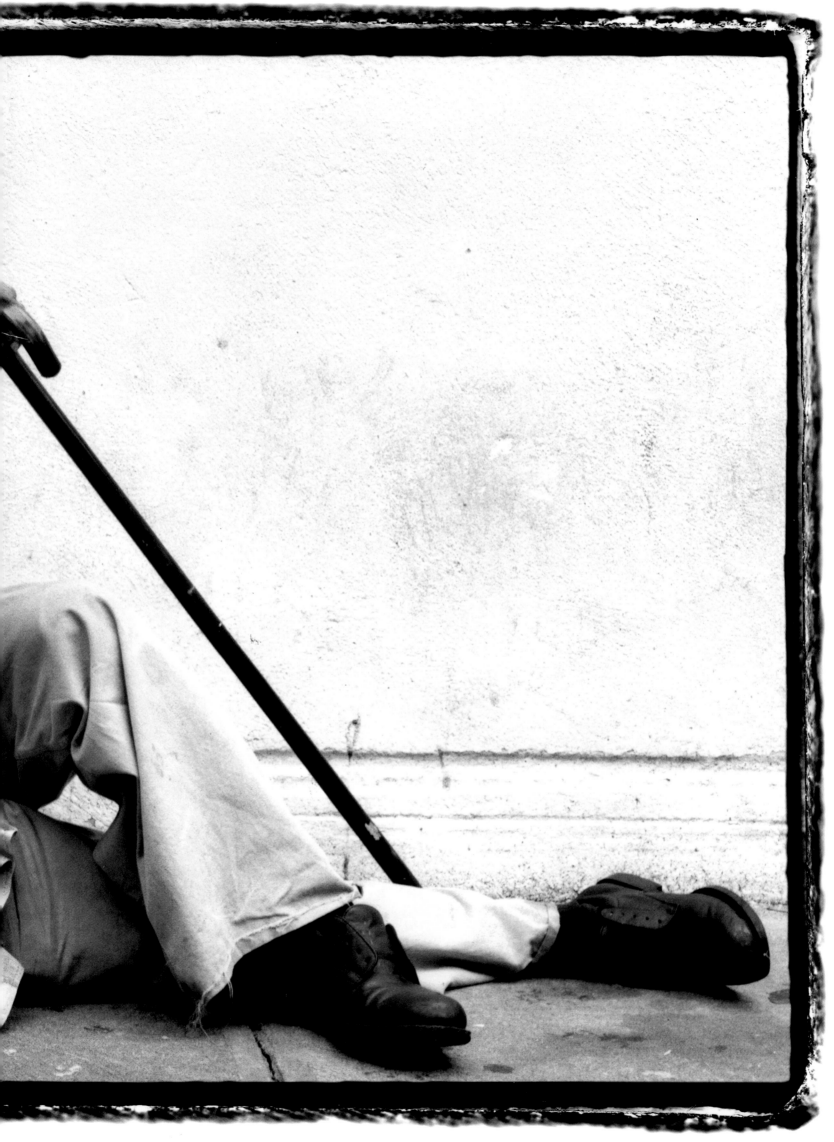

Ronald Rosario B., winter 1998

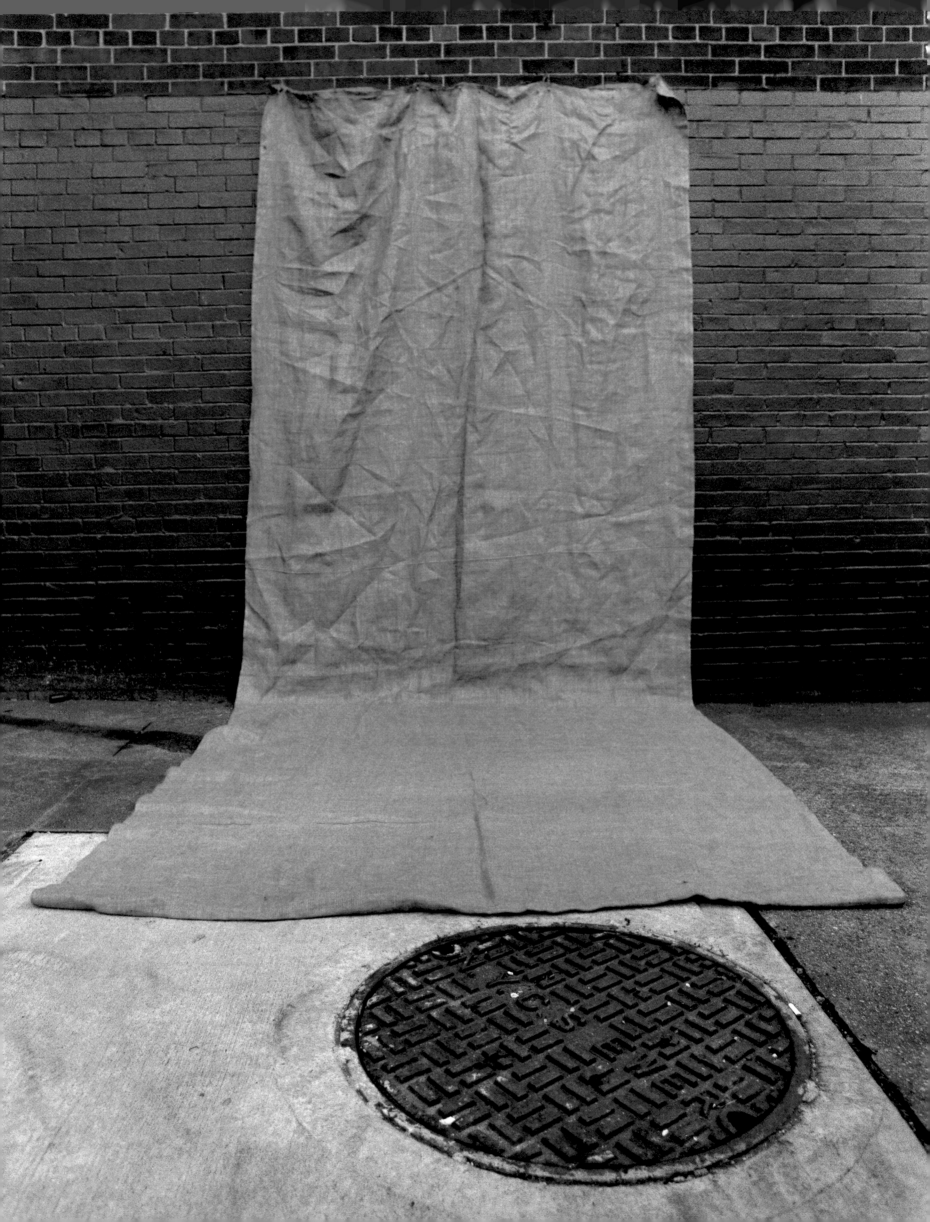

Sidewalk Stories

Vince

When I first encountered Vince, I found his hands transfixing. They embodied the aspect of his character that I wanted to capture in his portrait.

The hands, big and powerful. The hands of a good man. The hands of a man who has progressed through life with his head held high. Now, at sixty years of age, he spends his afternoons in the park opposite the Soup Kitchen, feeding the pigeons with remains of his meals.

Vince is proud of his Sicilian origins, and dreams of leaving New York. He maintains an unshakeable faith he will someday, persuaded that the one who is going to help him is his "best friend," Jesus Christ.

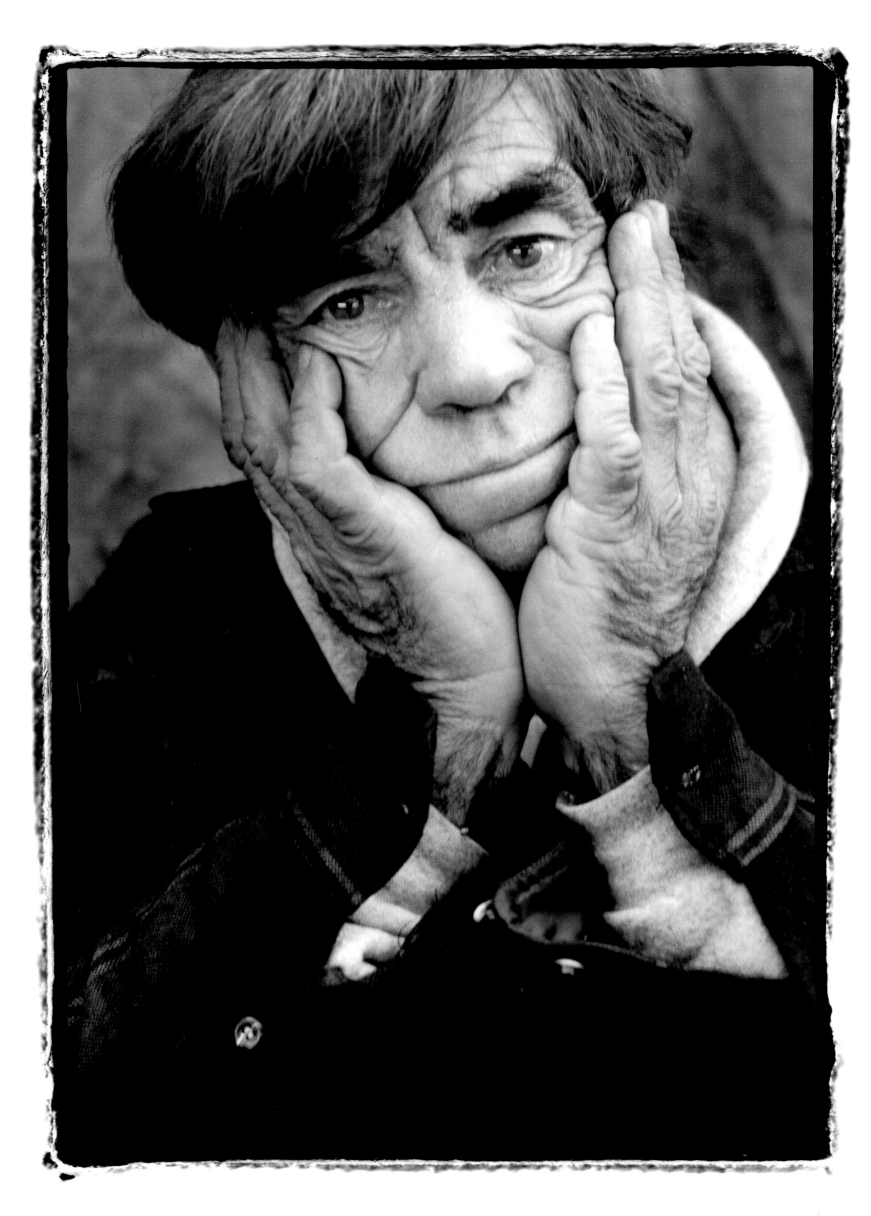

Michael and Goldie

Like everyone, Michael and Goldie never expected to become homeless.

Their story together begins about twenty years ago in Michigan where Michael and Goldie were married. They then decided to move to New York. Living in a squalid basement in Brooklyn, Michael worked as a maintenance worker, Goldie as a clerk in the Chamber of Commerce on Madison Avenue. Their income was enough to sustain their family of six—two children and two elderly mothers.

In 1996 Michael's HIV progressed from a dormant virus to a virulent one. Soon the intolerable pain forced him to quit his job, and subsequently, Goldie to quit hers in order to care for him. A few months later their building was deemed unsafe and condemned by the city. Michael, Goldie, their two children, and their grandmothers were evicted, left to live in the street.

During the warmer months, the good weather enables them to live on the streets, where they save money earned from odd jobs. In winter, they move to temporary housing in Queens or in Brooklyn, where the rent is affordable enough for their meager income.

When I last met with them in September 1999 their lives were about to change again. Goldie was diagnosed with HIV; and although medication would minimize its impact on their lives, she was pregnant with their third child. In order to apply for permanent supportive housing, the couple had to remarry. When I saw them, they were on their way to City Hall, and carried with them documentation provided by the Coalition For The Homeless to verify their social status. With the support of this type of housing, they stood a fighting chance of keeping their family together. With luck, this time, forever.

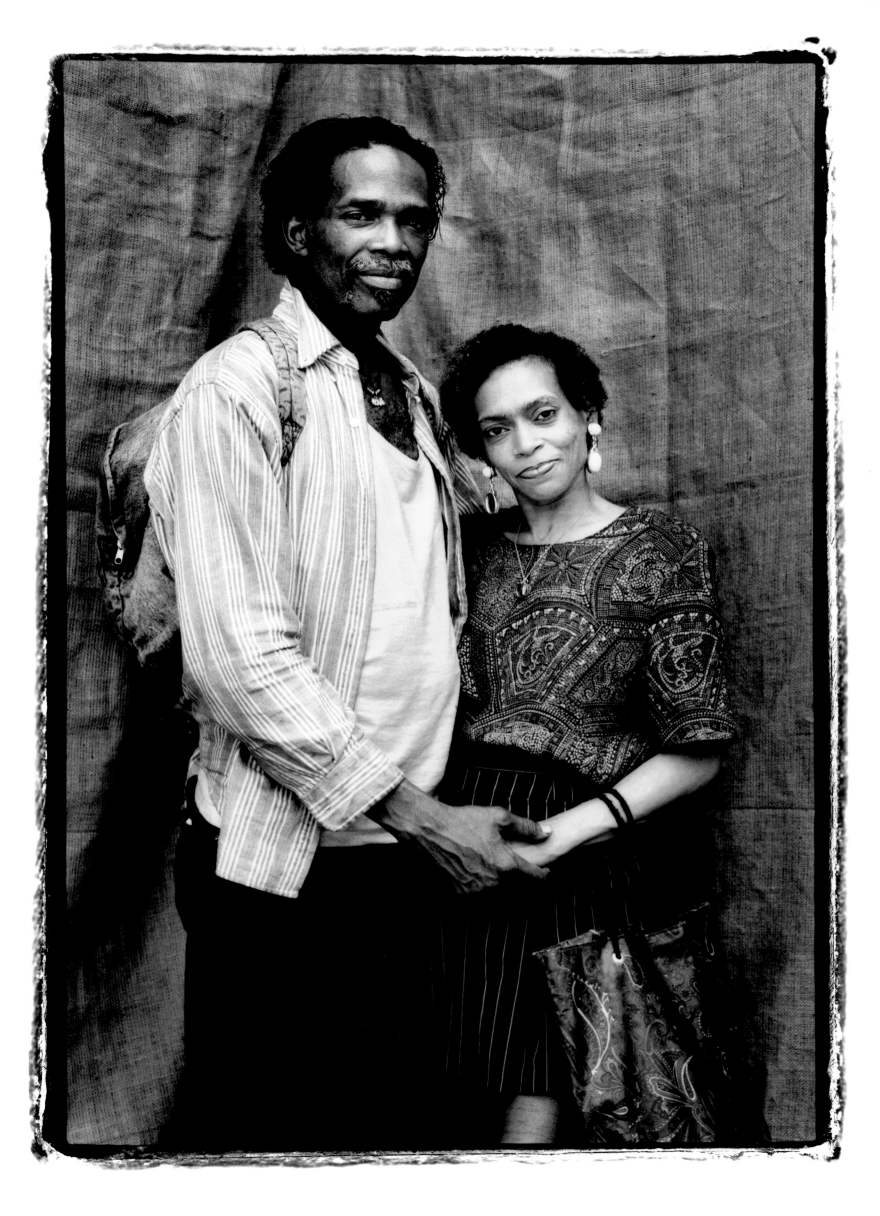

José and Steven

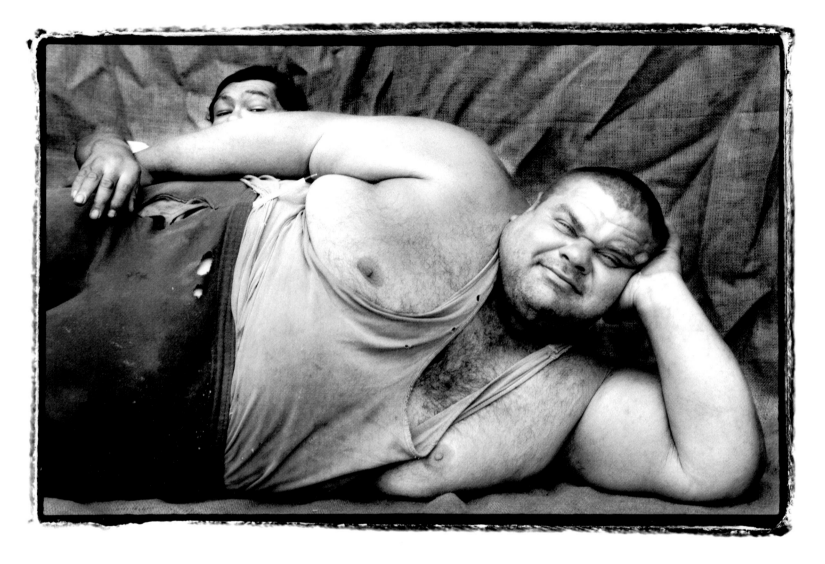

They are inseparable. Where there is José, you find Steven; where there is Steven, you find José. They are the archetypal pairing of the small one and the big one.

José, the small one, is nicknamed "Charles Bronson" because of his apparent likeness to the actor. Steven is nicknamed "big man" because of his size, although the name also suits him for his generosity, for which he is well loved by the guests of the Soup Kitchen. José and Steven share casual jobs, such as collecting cans and recycling old clothes, and split their earnings. Just like good friends would do.

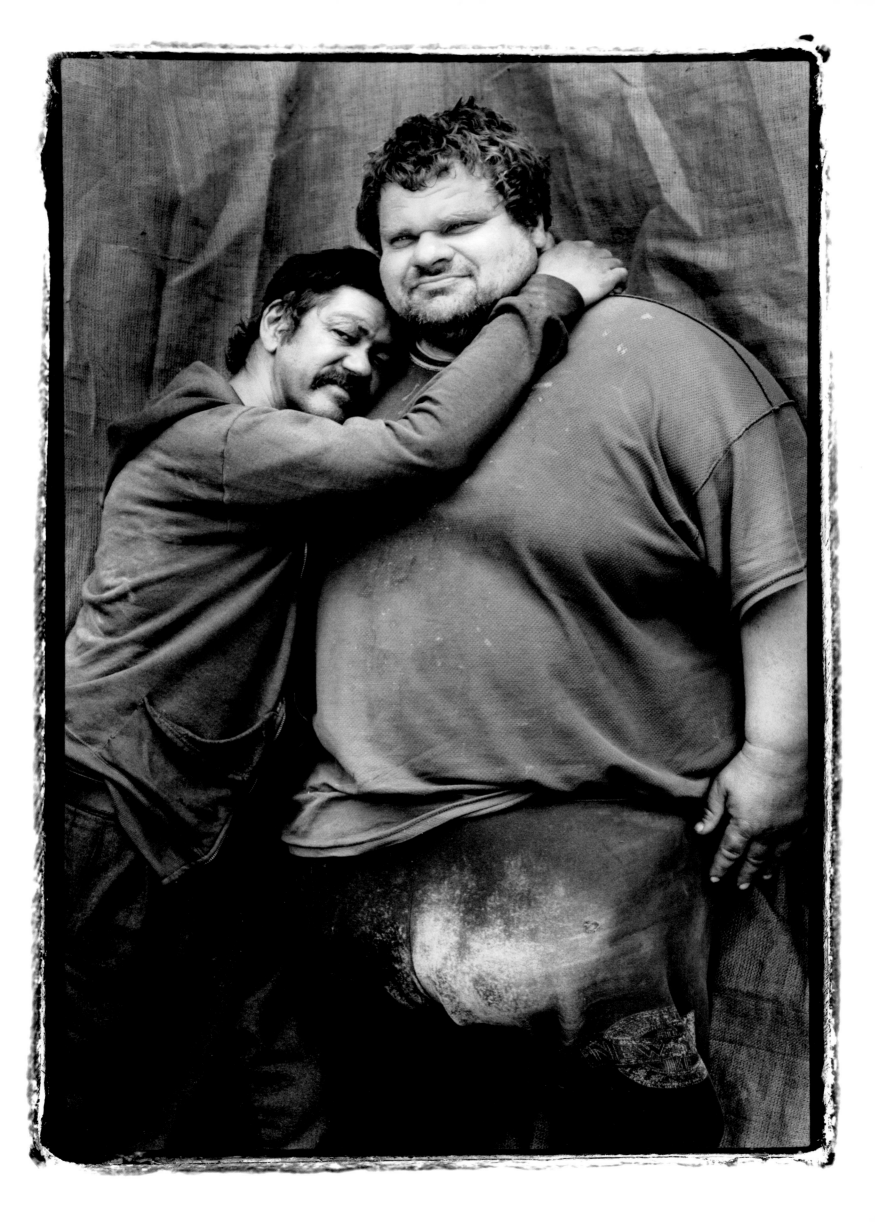

Thomas

I call him angel face.

Thomas is twenty; he was born in New York. He is all of twenty, and he sleeps on the benches in Central Park.

He wears a navy blue pea coat with three buttons missing; it is the remnant of his other life. Thomas dreamed of a career as an officer in the Navy. Ten months after starting officer's school, he had a violent fight with a superior, and was consequently discharged. This ended his dream.

When Thomas returned home, he first went to his father, who was working as a doorman. But there was no room in the father's life for Thomas. He then turned to his mother, who had moved to Vermont to begin a new life after having divorced Thomas' father because of his violent tendencies. Fearing that her son might share her ex-husband's predisposition toward violent behavior, she slammed the door in Thomas' face.

The dysfunction of his family, as Thomas sees it, is his father's alcoholism, which at its worst resulted in him trying to strangle his wife with a telephone cord.

Since then, Thomas has lived day to day. He was left with nothing except his navy blue pea coat, a tangible reminder of his broken dream. The metaphor of a dream, with three buttons missing.

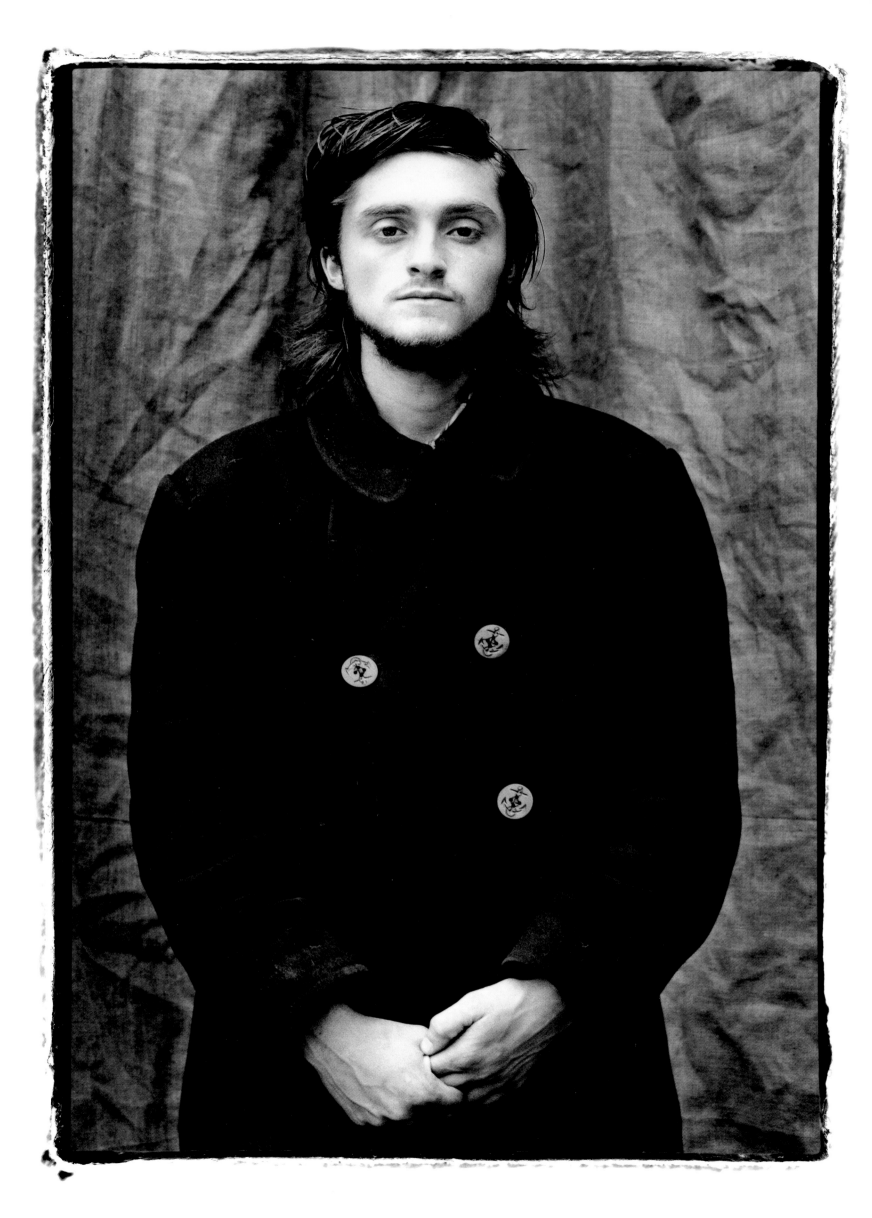

Over a recent
nine-year period,
more than
333,000
different homeless
men, women,
and children
resided in the
municipal shelter system,
representing nearly
1 of every 20
New York City
residents
(4.6%).

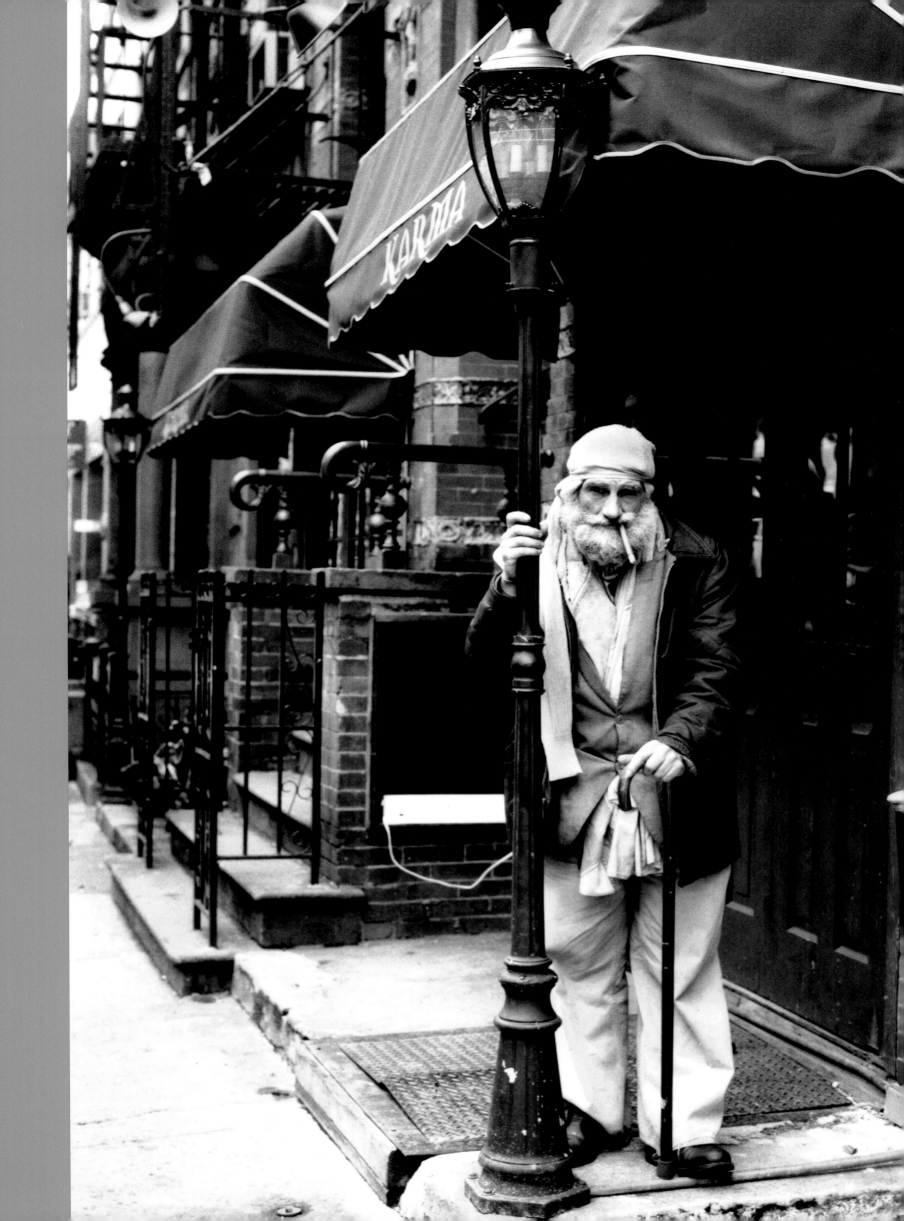

Darlene

Darlene has a plan. In order to survive in New York City without a home or a job, one needs an ingenious survival technique, and she has it: "promotional casinos."

Darlene's typical day begins at seven A.M., when she attends breakfast at St. Francis Church. She then has lunch in the Holy Apostles Soup Kitchen. After feeding the pigeons at The Waiting Park, Darlene spends her afternoons collecting cans from the street. Toward evening she makes her way over to a soup kitchen on the east side for dinner.

After dinner, she puts her special plan into action. Darlene goes to the Port Authority bus terminal on 42nd Street and 8th Avenue and, for fifteen dollars, purchases a round-trip bus ticket to Atlantic City, the city of casinos in New Jersey. On the bus, she has a warm, dry place to sleep for the four hours it takes to get there. Upon arriving, a "promotional casino" dispenses $25 in chips to all of the bus passengers, an incentive for them to gamble at the casino. Without placing a single bet, Darlene cashes in her colored tokens and heads back to Manhattan on the return bus. Sleeping all the way.

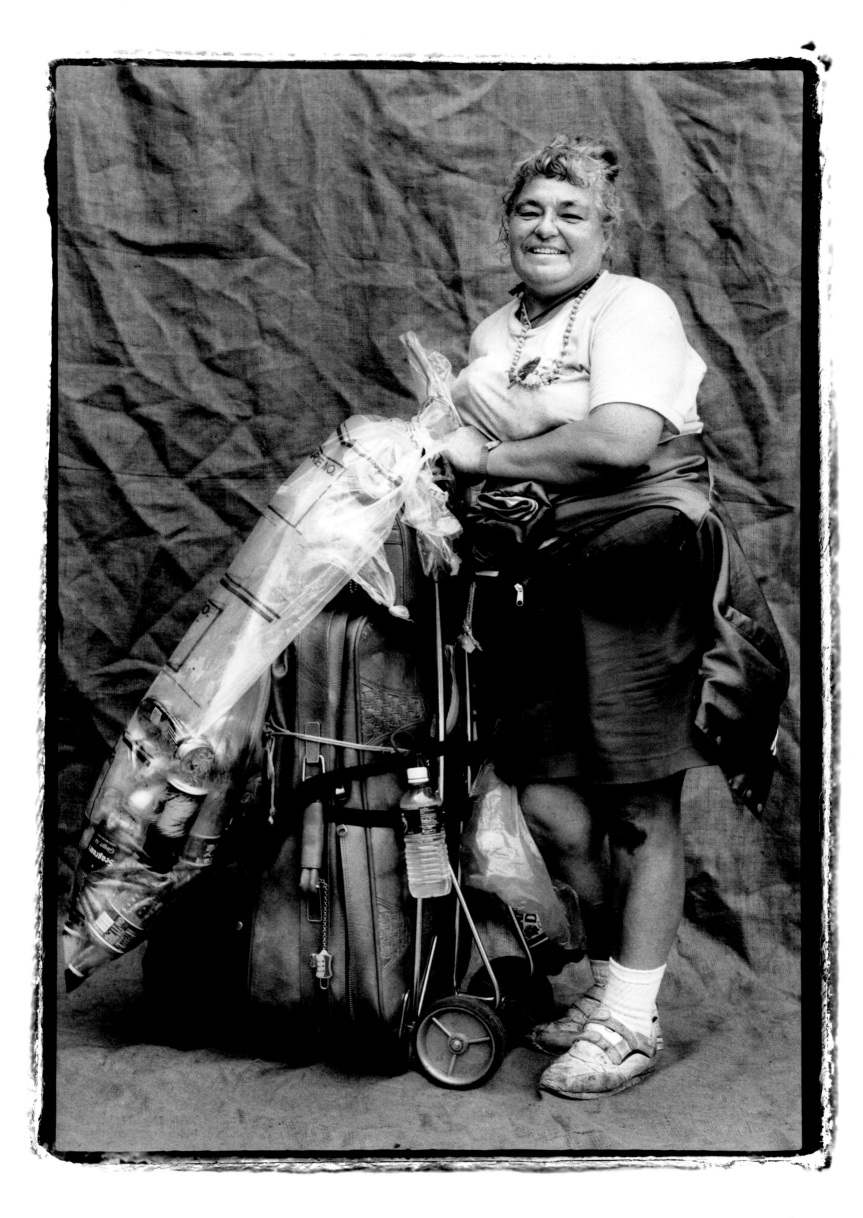

Augustine and Nilda

He has the face of a Russian exile who has just landed on Ellis Island. Hers is the face of a Balkan psychic who reads tarot cards at Brighton Beach.

They seem a perfect couple.

But appearances can be misleading. Augustine and Nilda are just good friends. She's from down South. He's 100 percent Mexican.

Their paths crossed at the Soup Kitchen, where a hot meal and a blanket made solid ground for a new friendship.

The rest you can read in their eyes.

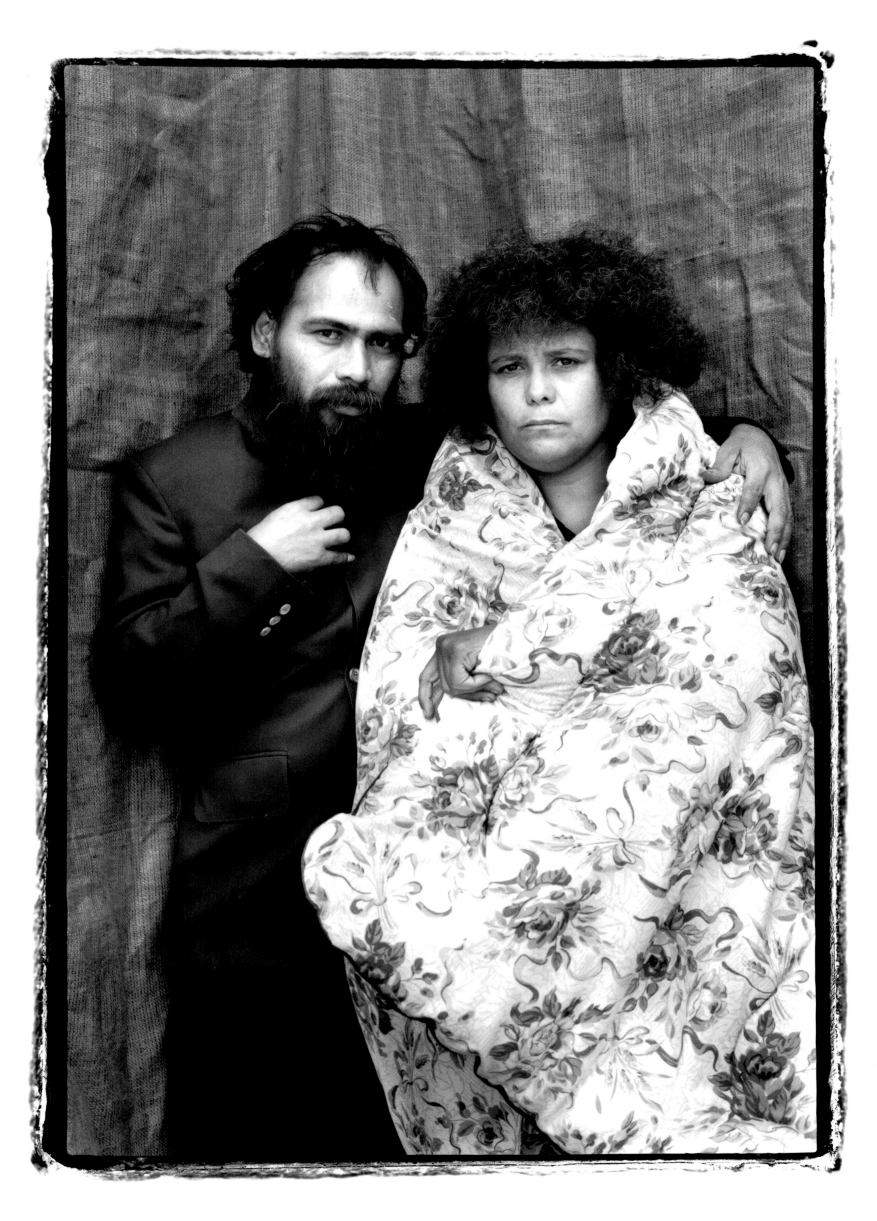

Ernest B.

One afternoon in late summer, I was setting up my outdoor studio next to the Soup Kitchen. The backdrop and photo equipment sparked Ernest's interest. As he approached me, he said that seeing me working made him feel at least thirty years younger. In his youth, he worked in a photo lab and could easily speak about film speed, lighting, darkrooms, and cameras. During our conversation, I learned much about his distant past and recent present, but very little about the thirty-odd years in between. I'm sure, though, based on his memorable anecdotes that his life was filled with remarkable experiences. He is a man not afraid of an unforgiving camera lens, nor of life itself. Even after a tragic accident left him with metal screws in his legs, even after several months of hospital care left him without a buck or a job. Even though now, at 65, he is homeless. Ernest doesn't complain. He's a man who often thanks God and destiny.

"If that same accident [had happened] in Africa, or in one of those third-world countries, I would be dead now," he tells anyone willing to hear his story. Hearing Ernest's soft voice and seeing his peaceful smile, he becomes strongly present, standing on top of the world.

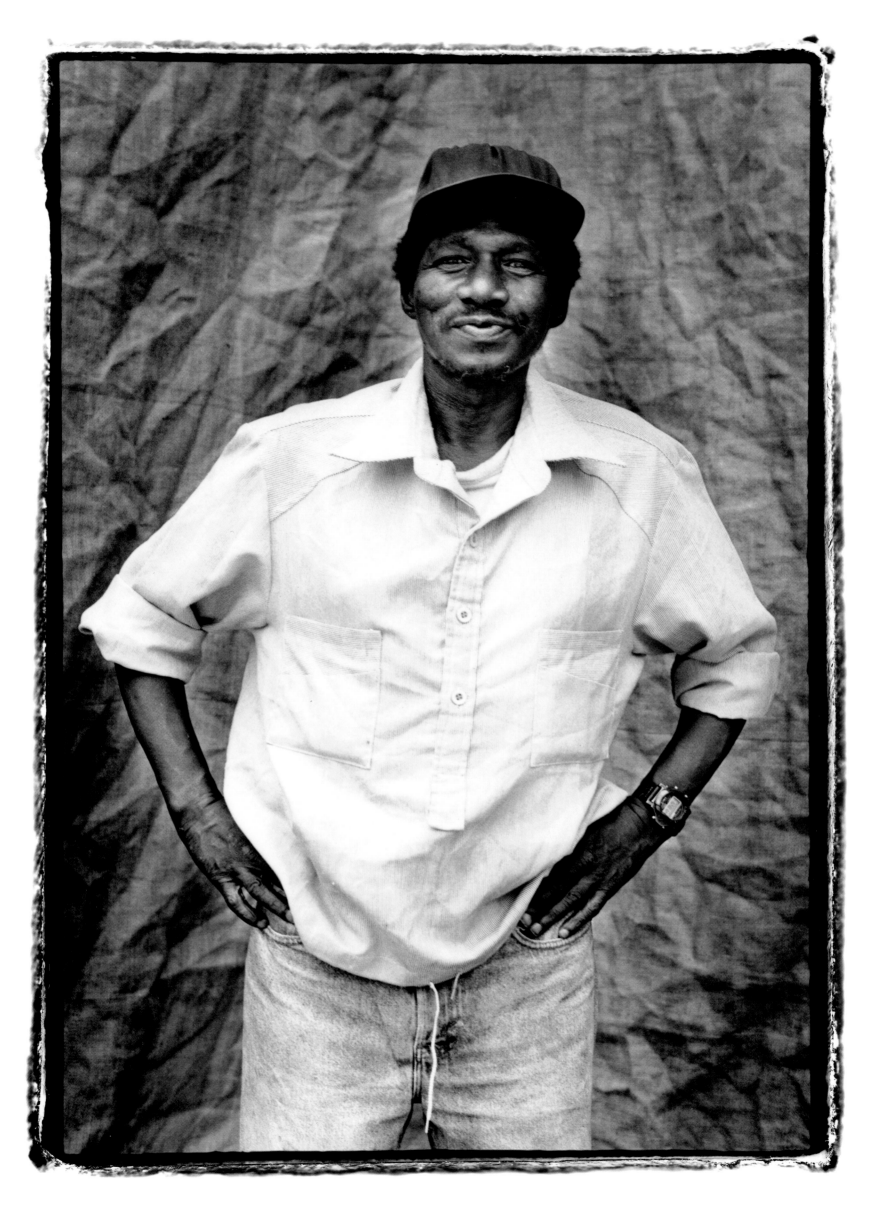

Willie B.

At the beginning of his story, Willie was a cop.

In the streets, when something was happening, people would call to him: "Willie! Help!" And Willie would always be there, ready to aid and assist in his blue uniform, too baggy and too short for that slim and tall body.

Suddenly people stopped calling for him.

Willie lost his uniform, and began wearing old used clothes. He was surviving now by delivering groceries or working for a moving company. Willie, the former cop, became one of those people whom policemen regularly regard with suspicion, sometimes with rage, rarely with pity.

Now 52, Willie lives on the street, where hidden under a worn-out fisherman's hat, his proud and silent face floats between the ground and the sky.

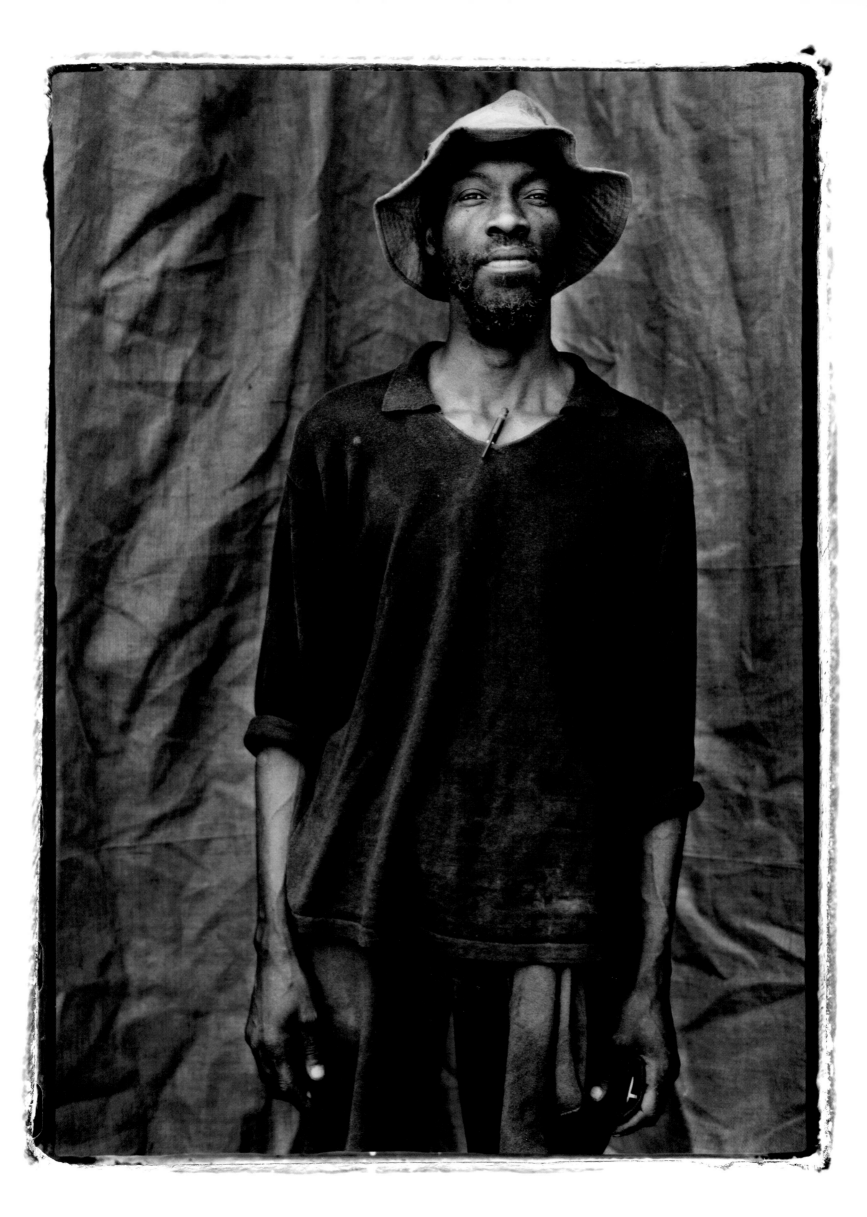

In New York,

the cost of a

bed in a psychiatric hospital

$113,000

per year,

the cost of a prison cell is

$60,000

per year,

the cost of a family shelter unit is

$36,000

per year

and the cost of a shelter cot for an individual is

$23,000

per year.

In comparison,

the cost of a supportive housing apartment

with on-site services is

$12,500

per year.

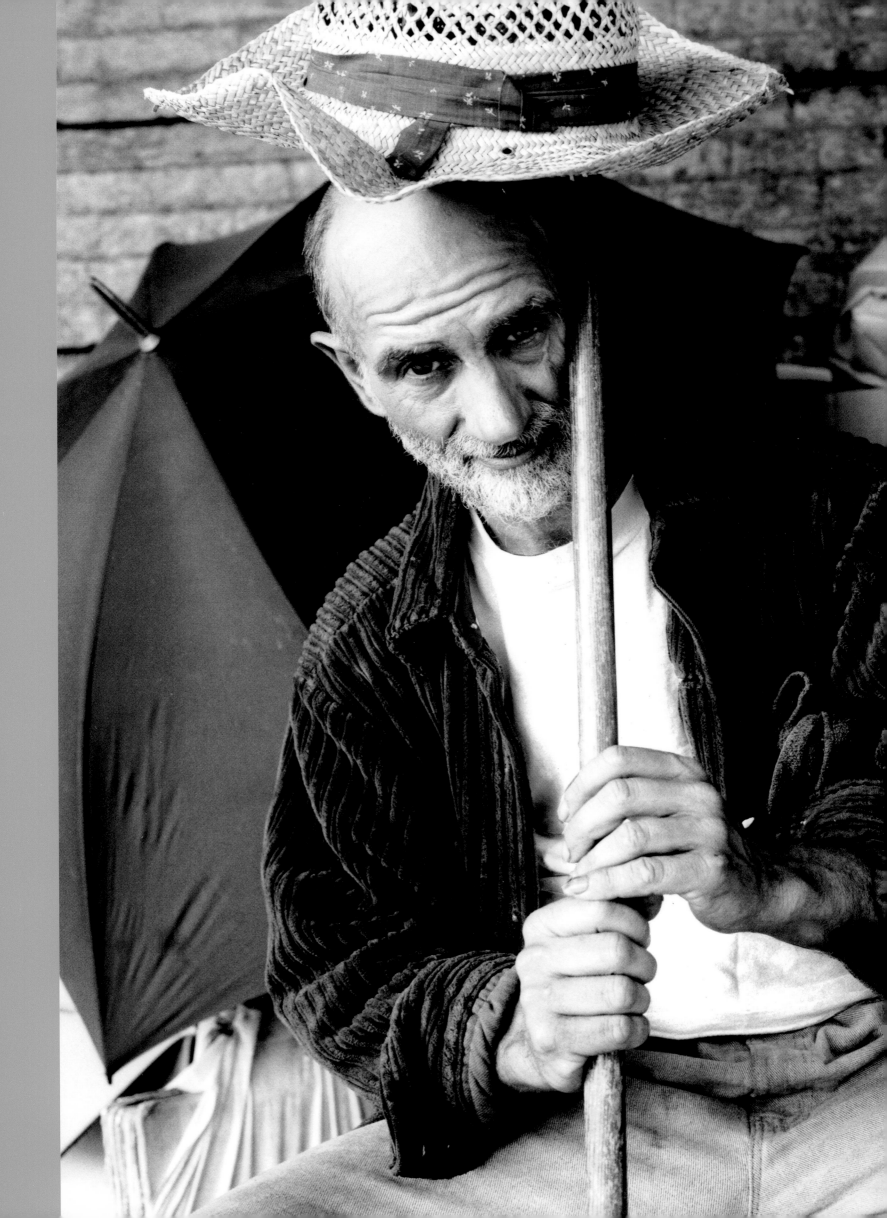

Scott

Today Scott looks like a different man; when the heat comes, he shaves his beard and mustache off and starts anew. This is Scott before and after, the winter face and the summer face.

Not even his Scottish origins and refined, cultured intellect were able to keep Scott off the streets. Though homeless now for several years, Scott hasn't given up being a philosopher and an intellectual. He is an eternal student. He never stops reading newspapers and books about politics, wisdom, and poetry. He takes notes, which he collects inside a plastic bag he carries with him at all times, tied to his waist.

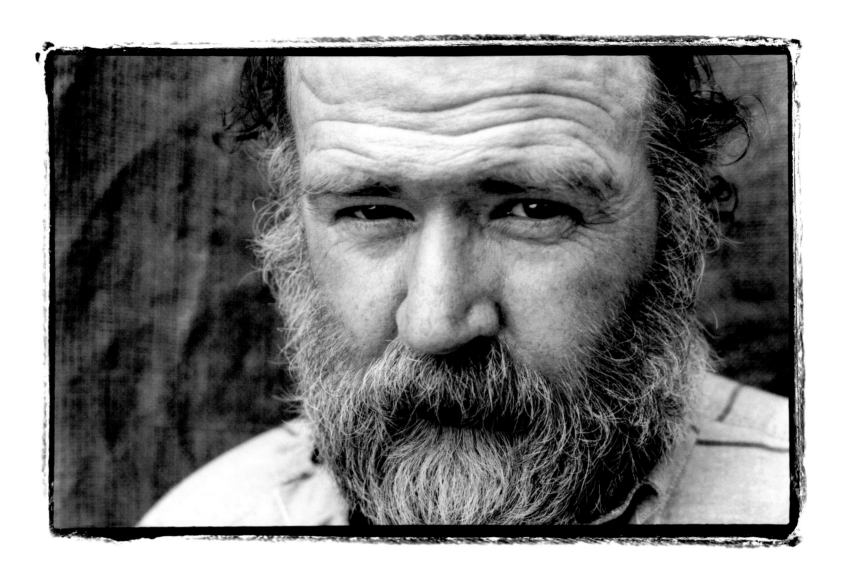
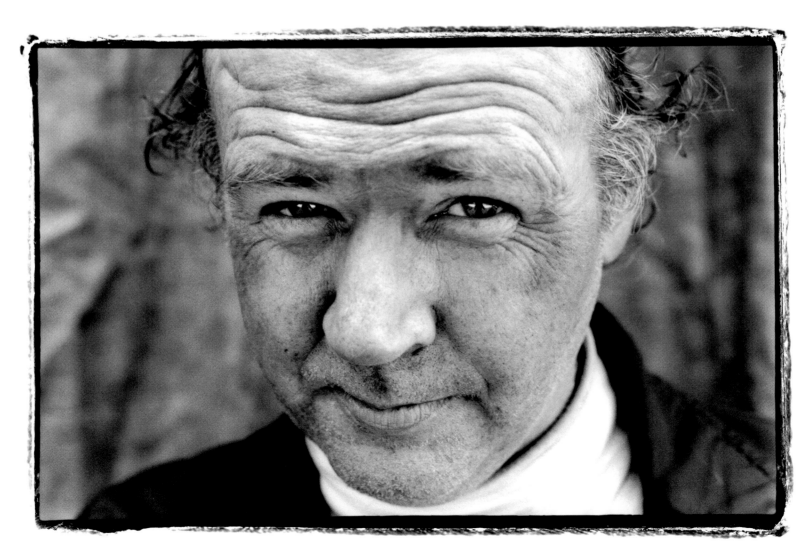

Scott's magic bag contains some of his knowledge and most of his life.

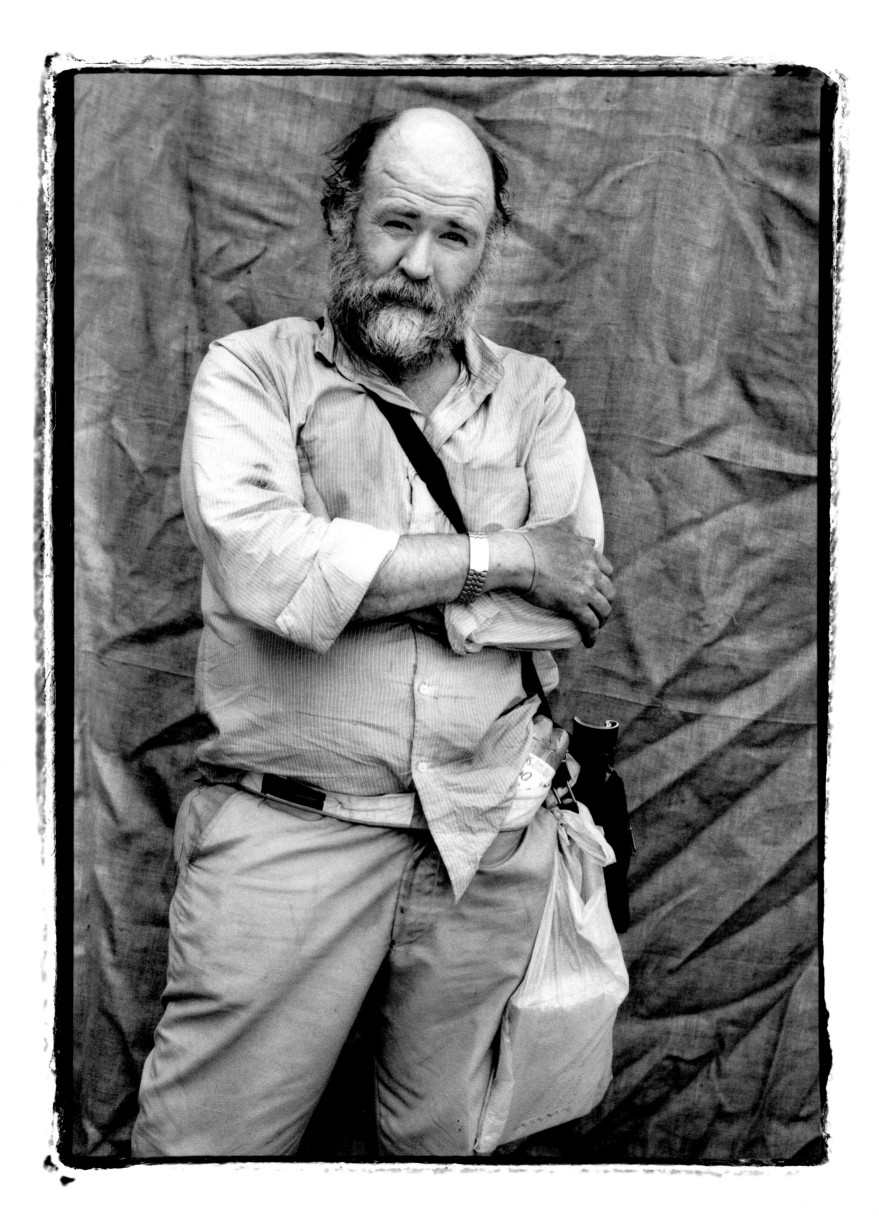

Pedro, Carmen, and Ed

Pedro, Carmen, and Ed are good friends. They spend many of their nights together in a dormitory in the Bronx. Carmen hasn't got any legs with which to stand, but can always rely on her buddies for help—evidence that the notion of standing on your own two feet is as meaningful in metaphor as it is literally. One can have legs and never truly stand on them; one can be without them and never lack support.

Being homeless needn't signify being hopeless if you stand on your own two feet. Any way you can.

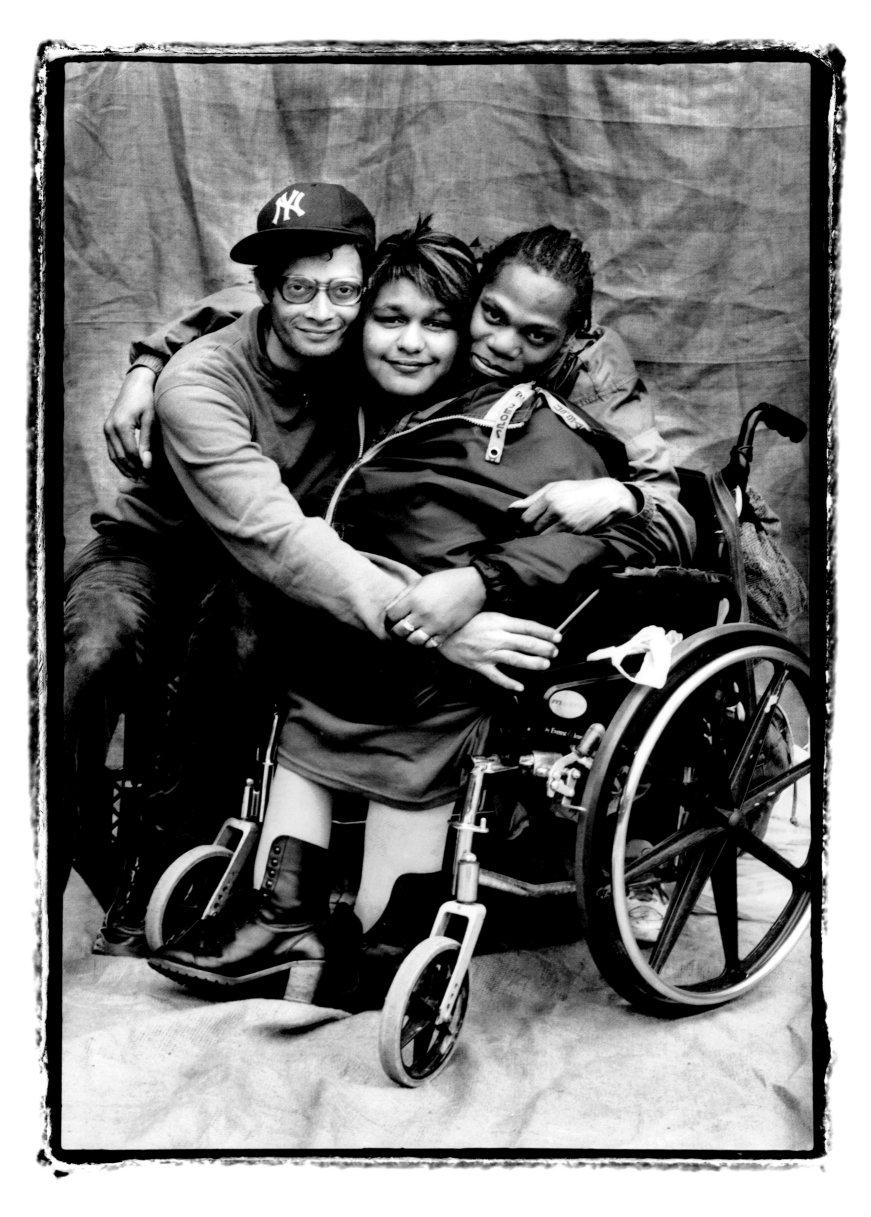

Byron

Byron, with his big dark eyes, is a genius in disguise who can recite by heart the laws of thermodynamics.

Byron, the proud inventor of the solar-powered walkman; Byron the Mexican. He lives on the sidewalks of New York, but has spent the last five years reading and studying in the public library. He speaks no English. He spends his nights across the Hudson River in New Jersey, in an abandoned factory illuminated only by the blinking lights of the river barges.

Byron is working on an engine made out of trash, stuff apparently worthless to those who discard it, but invaluable to him. It will be an extraordinary creation, about which he will say no more.

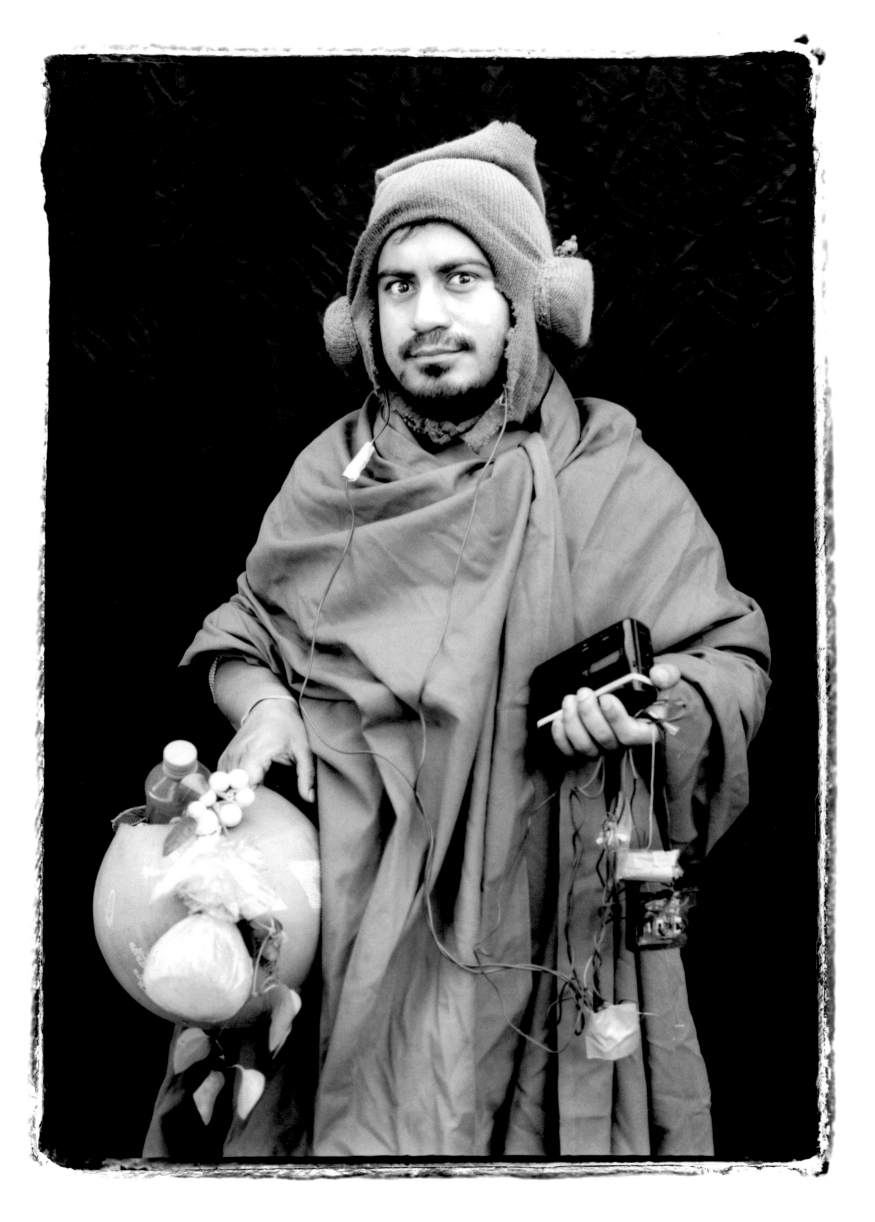

In New York City,
70%
of homeless people
residing in the municipal
shelter system are
parents and their children.

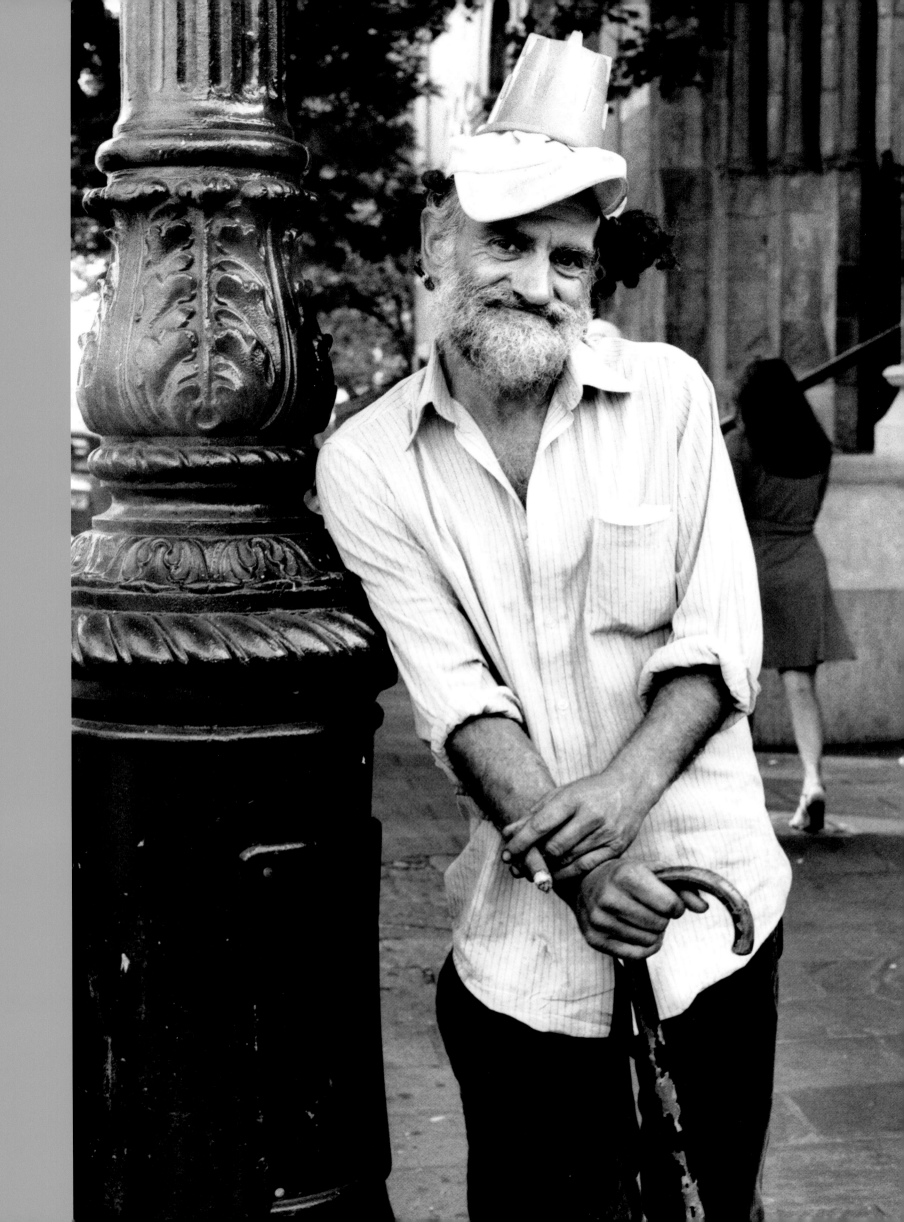

Heidi, Jordan, Jarrell, Janice

At the beginning of the year 2000 in New York City, over 100,000 people live on the street. Of this figure, a mere twenty-five percent are "lucky" enough to end up in one of the city's notorious public shelters. Of this amount, almost three-quarter are mothers who carry the burden of sheltering not just themselves, but also their young children, the majority of whom are under the age of six.

Heidi is a mother. Jordan, Jarrell, and Janice are her children. They spend their days around the Soup Kitchen. At night they return to a public shelter. Heidi's husband is in prison. The kids rarely see their father. This picture is for him, to keep up hope.

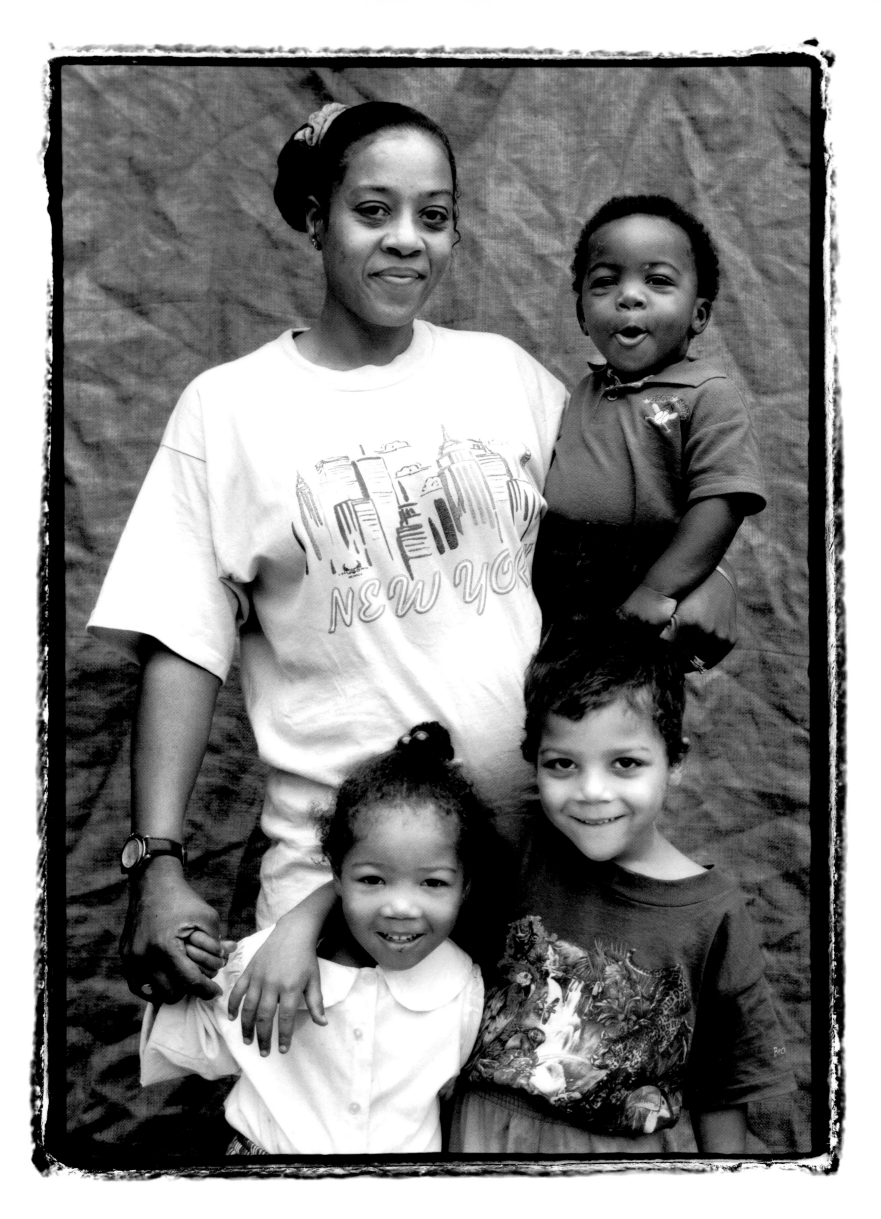

Jerry

Jerry has the reserved elegance necessary to wear a tuxedo with true class, even though he has Parkinson's Disease.

Originally from Puerto Rico, Jerry has lived in hundreds of different places. He has found refuge in countless basements, derelict buildings, ramshackle sheds, and abandoned warehouses. But he was always asked to leave by those around him, sometimes on good terms, sometimes not. Now he lives on the sidewalk. Every morning he stands in line and waits for his meal. In his trembling hands, I see the instability of his life, and his need of a secure place.

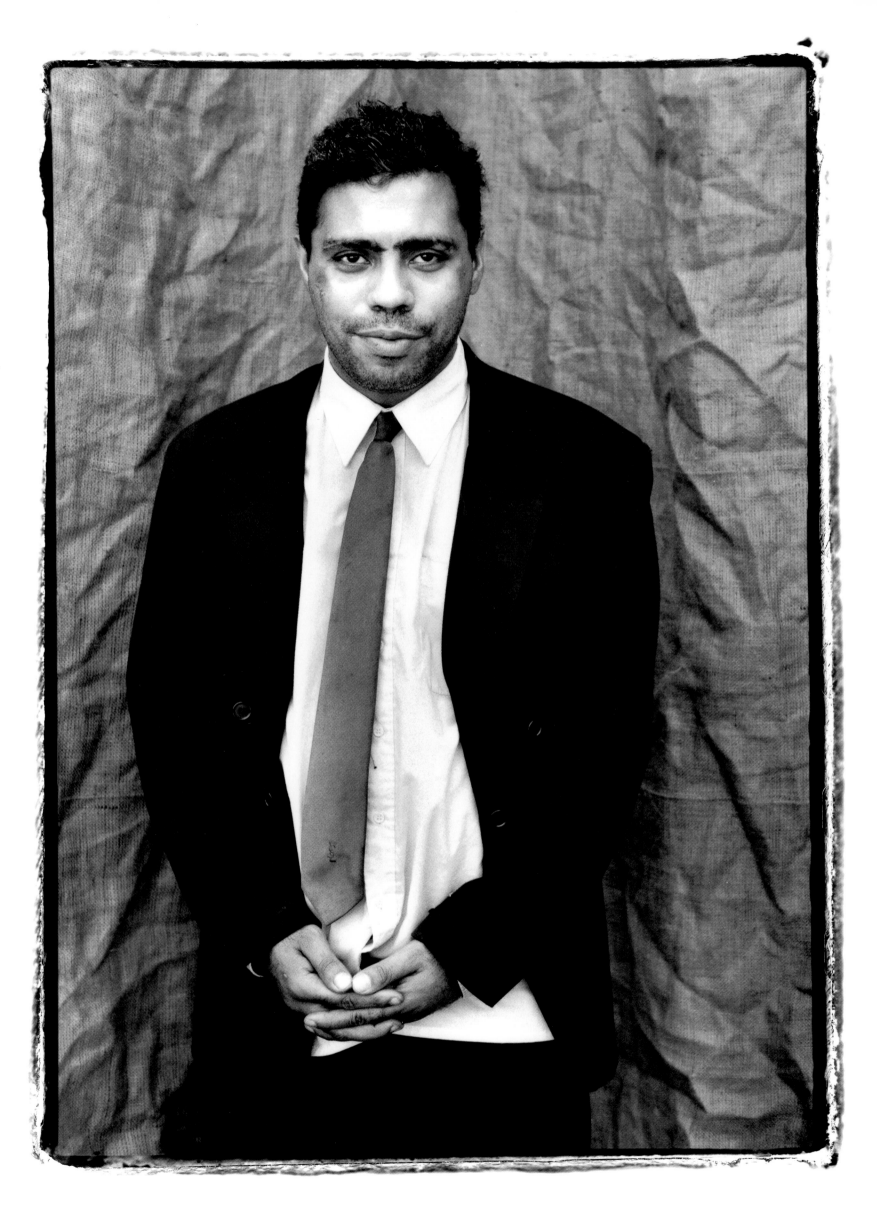

Anthony

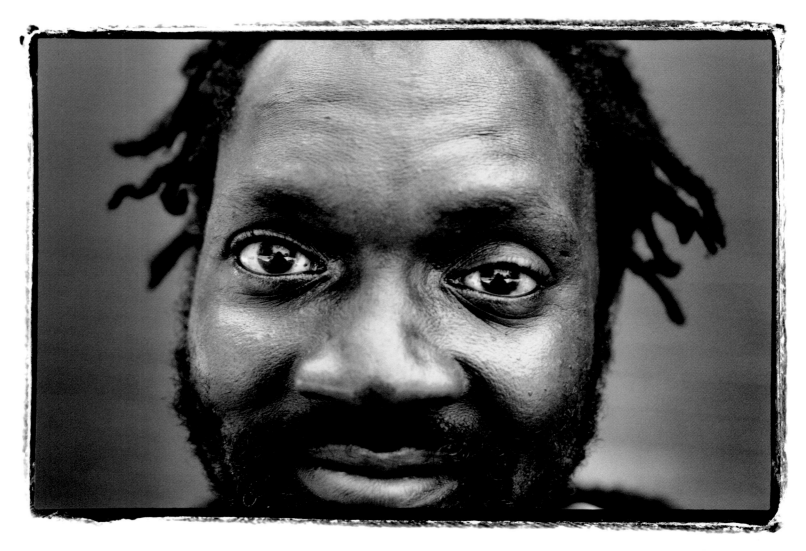

There was a time when Anthony used to sleep in a basement in the Village. When the tenants of the building discovered him, they threw him out. He fled to Boston first, then to Los Angeles. But in the end he came back to New York. He survives, thanks to the Holy Apostles' meals and the few bucks he earns looking for "second-hand stuff" he finds in the trash and sells as a street vendor on the corner of Sixth Avenue and Eighth Street. But sometimes he disappears. Still, everybody at the Soup Kitchen knows that sooner or later Anthony comes back. Always.

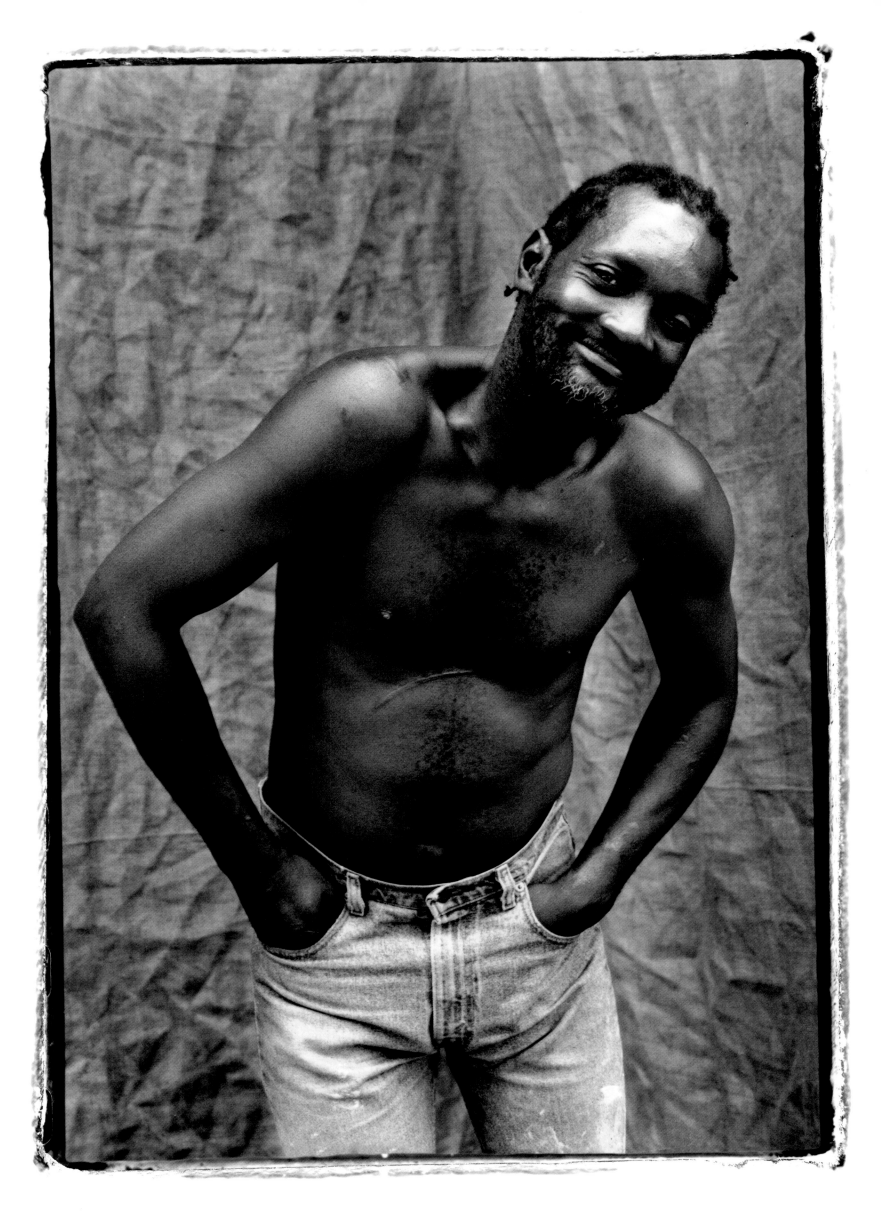

Willie N.

Willie used to be an artist. Then, something happened. Nobody knows exactly what. You can ask him, but you will never get a straight answer. He ended up on the street, and at about 50 years of age, he became a regular at the Soup Kitchen.

Now he's given to tirades about life's incongruities, wearing the old hippie clothes he finds here and there. He poses in front of the lens with his arms spread out, like a remorseless metropolitan Christ-figure. But his face is serene.

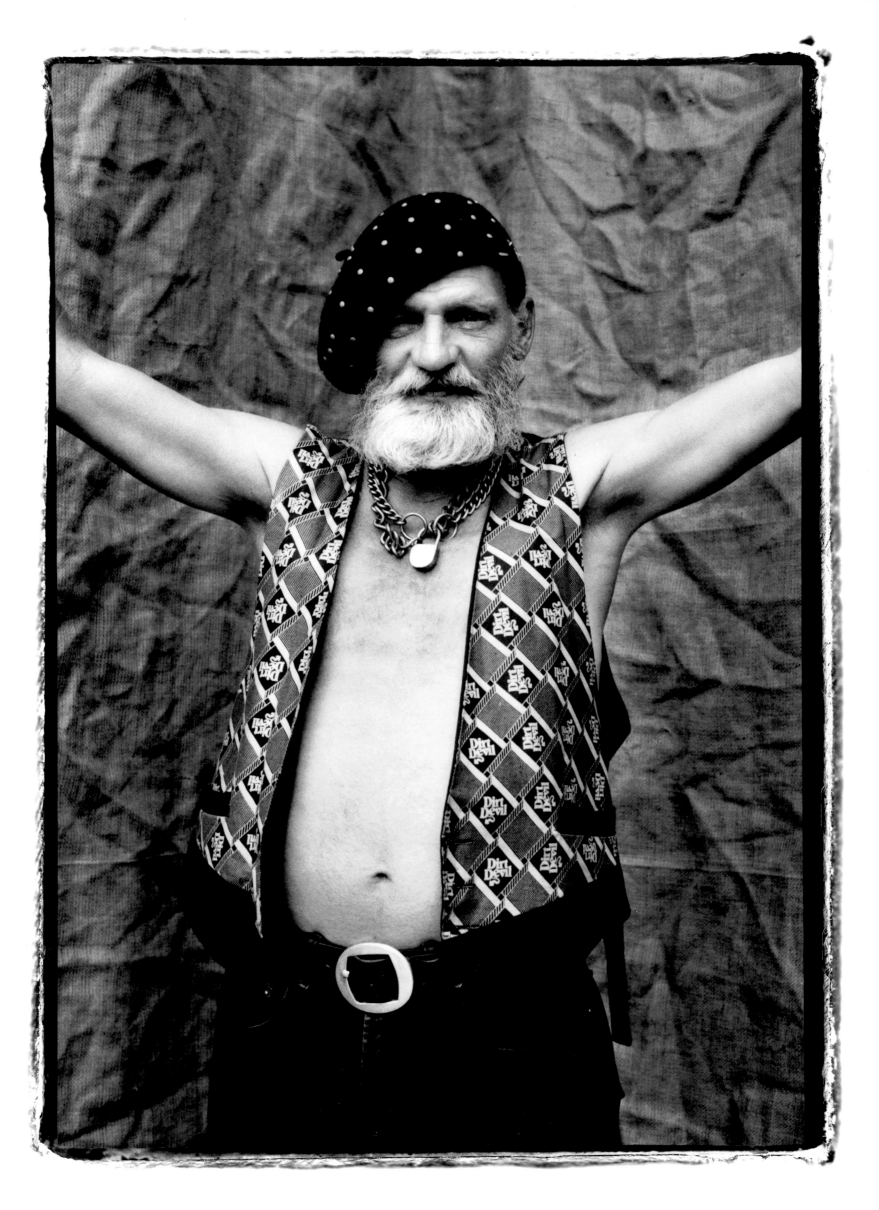

From the early 1980s
to the year 2000,
the number of homeless New Yorkers
residing each night in
homeless shelters increased by
more than
75%.

From 1994 to 2000,
the City of New York reduced
the number of new apartments
produced for homeless families
and individuals by
75%.

Ronald, winter 1998

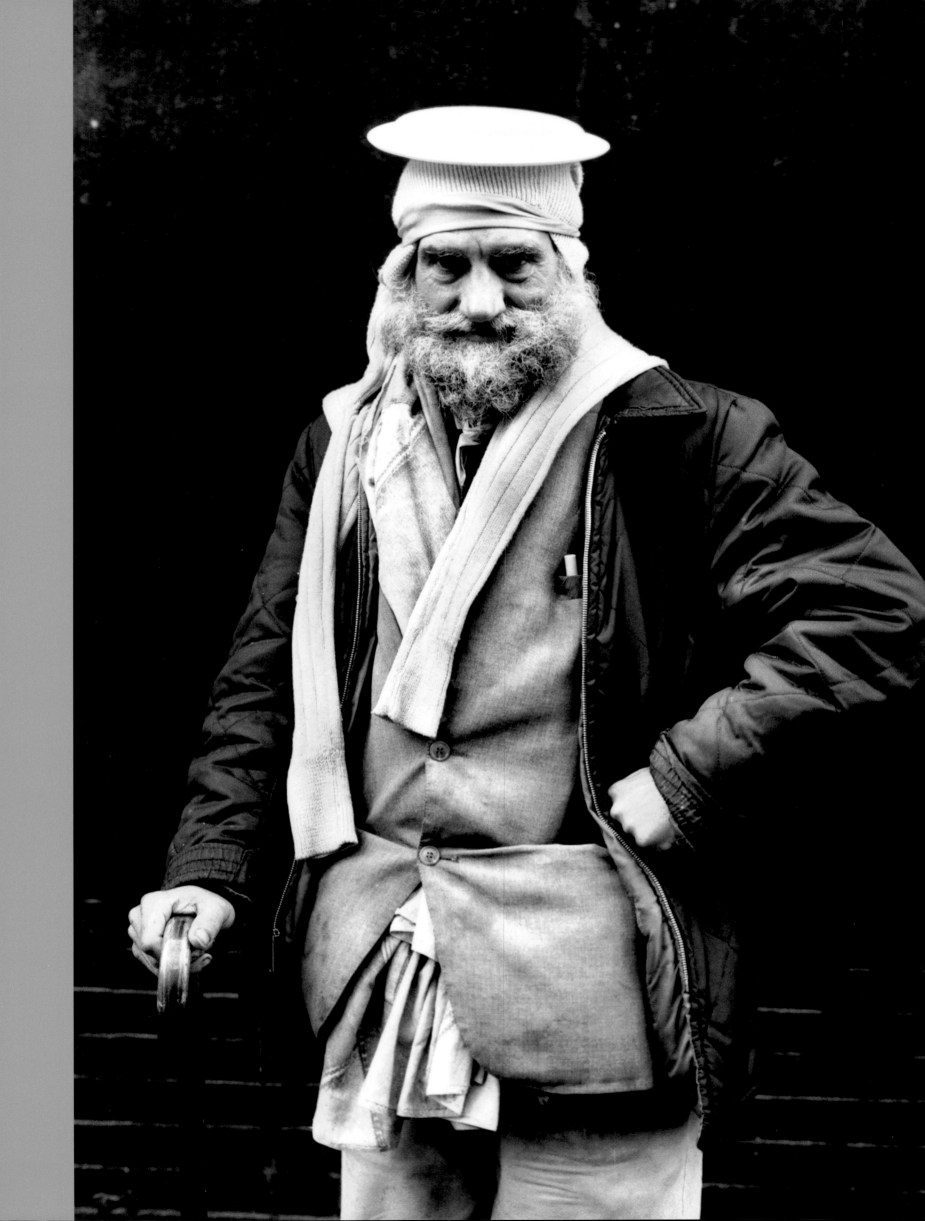

Agha and Singh

Singh wanted a picture with his new friend.

Singh is Indian, Agha is Pakistani. Singh appears calm and tranquil, but under his thick beard he is devastated by scars. He once made his living working in a gas station in Pennsylvania. One night, Singh found himself involuntarily involved in a large bar fight. His best friend was killed, but by some miracle, Singh survived. This convinced him to leave everything and flee to New York to live on the streets.

Agha is the reserved type who likes to keep to himself. It was an effort to compose this picture, and impossible to learn anything about his past.

Champale

Very often when you're homeless in New York, you don't even have the option of a public shelter. Champale is one of the many in this situation.

One day a cop found him in a park, taking a nap on a bench. For this he was fined $125. In New York, a homeless American citizen who lacks the privilege of shelter lacks also the small luxury of a public park bench.

One hundred twenty-five dollars for someone like Champale means picking up cans in the street for over a month, every single day. If he doesn't make it, he is subject to arrest. To avoid jail, you must pay, and in New York you can't afford to fail.

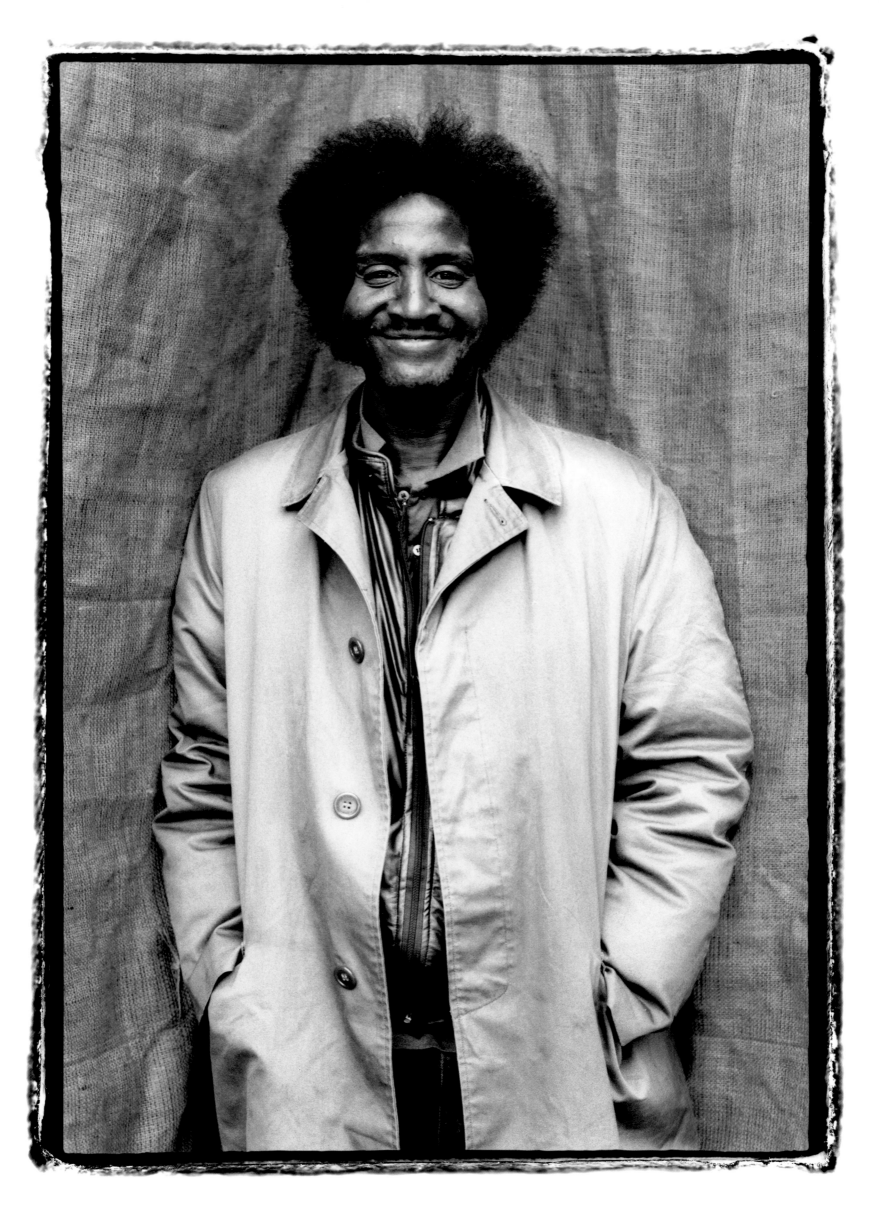

Libby

Those who have the pleasure of knowing Libby are unflinching in their acceptance of her boundless energy.

Libby came to New York from Cuba. She is a grandmother and a Soup Kitchen regular who is inseparable from the trolley with which she wanders the New York City sidewalks. Almost daily, Libby has lunch at the Soup Kitchen, eating two meals herself, only to return to the line in order to fill her trolley with the extra food and beverages she will distribute to those who have less than she has.

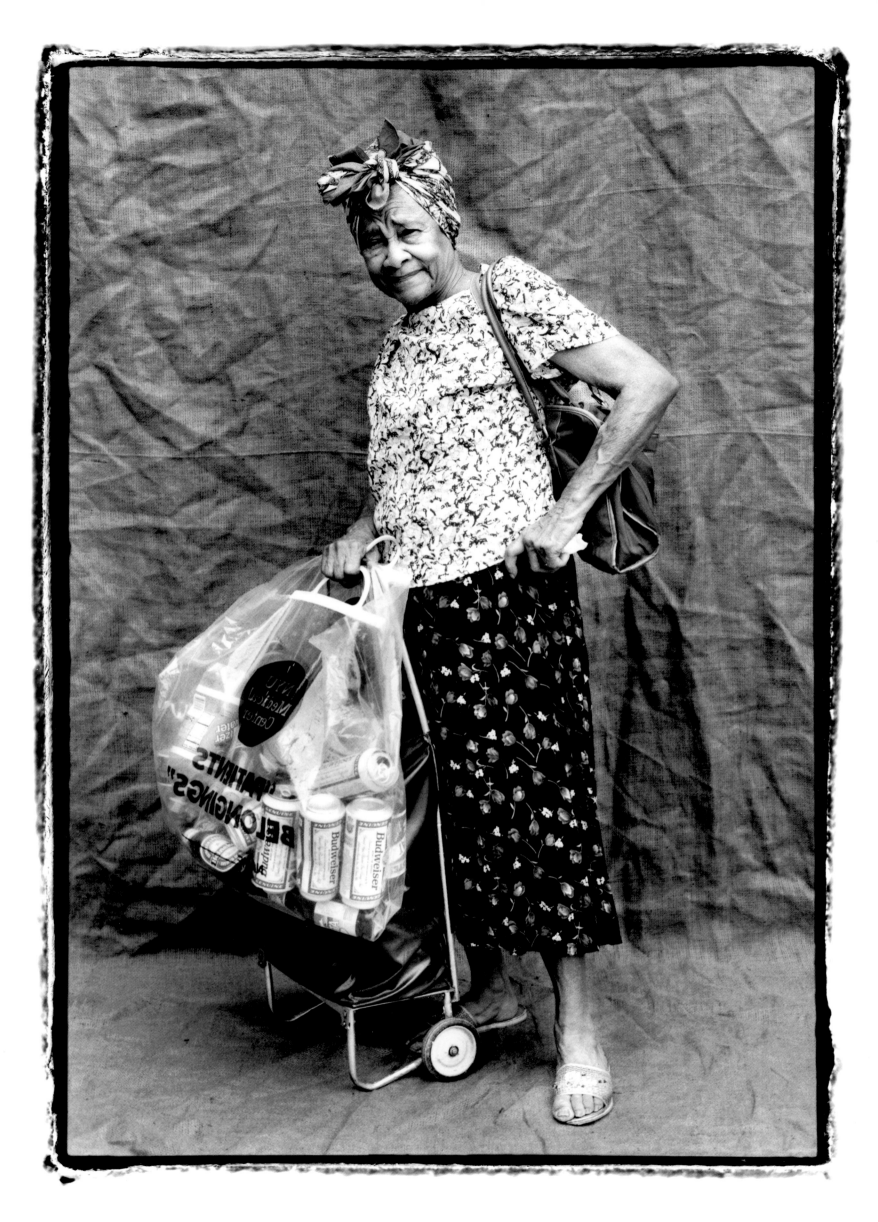

Eeyuel

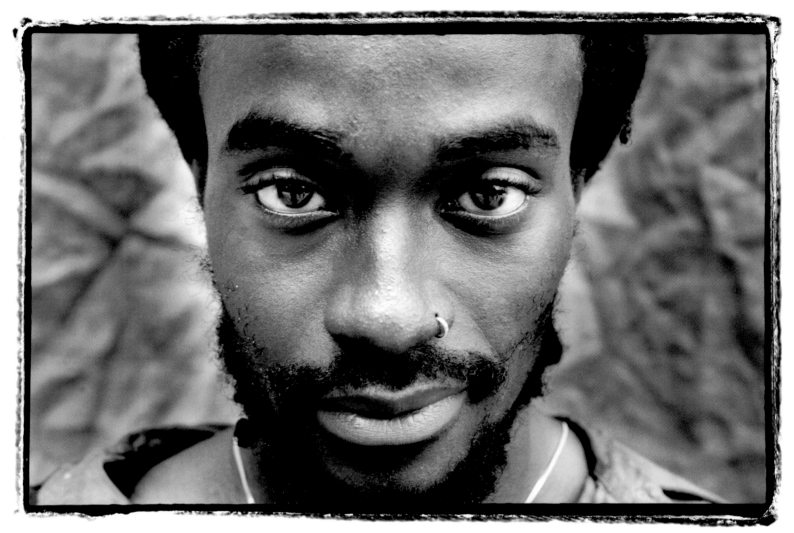

Eeyuel was born in Ethiopia twenty-three years ago. He moved to the States with his family when he was a teenager, and went to college until he was nineteen. His schoolmates teased him mercilessly, and soon his life became unbearable; he was isolated and outcast. He decided to disappear, to leave his family and live on the street.

The essential ingredients for a life on the street: a couple of shirts, a pair of pants, a blanket. For Eeyuel, there is one addition to this list of fundamental items: a page from a history book with a portrait of Haile Selassie, the twentieth-century Ethiopian king who looks just like him.

As soon as Eeyuel looks into the lens, poised in his commanding six-foot, three-inch stature, one could easily imagine him in a career as a male model.

But then he begins to stare through the center of the lens with those piercing eyes, and the blanket wrapped around his body becomes a regal robe, and the park in front of the Soup Kitchen becomes his kingdom of Ethiopia, one hundred years ago.

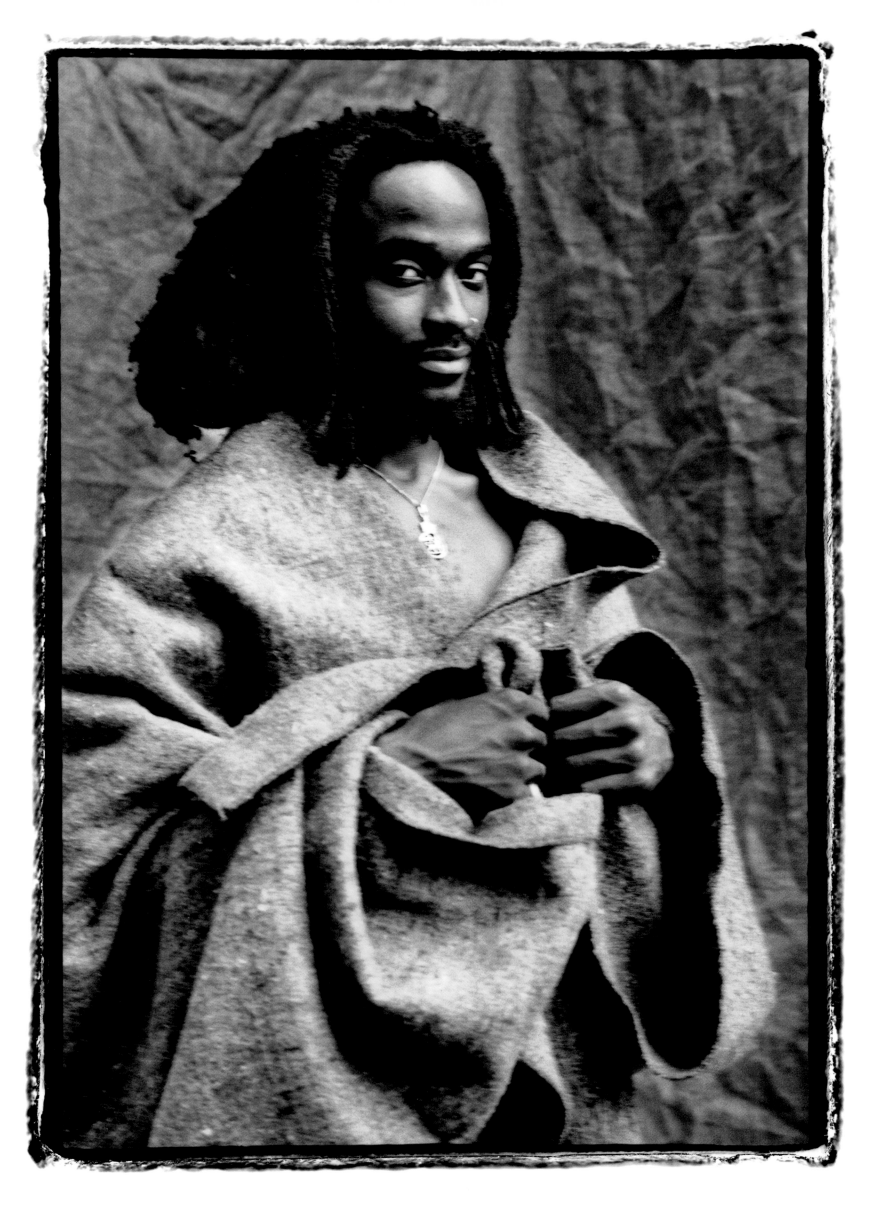

But this is another story—Eeyuel's story.

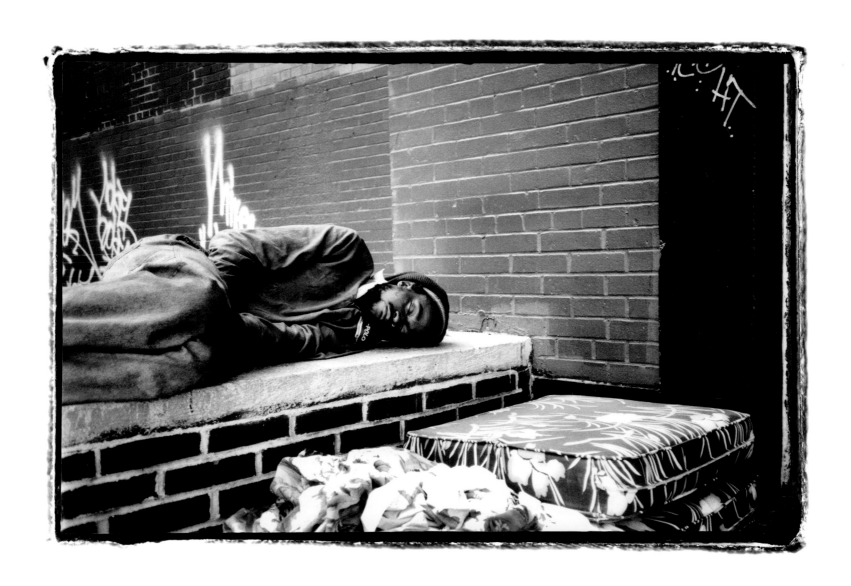

Janette

Janette was born in Israel thirty years ago. She doesn't visit the Soup Kitchen very often, but when she does, she silently wanders among the others with her walkman glued to her ears. A spectrum of sound divides her from the rest of the world.

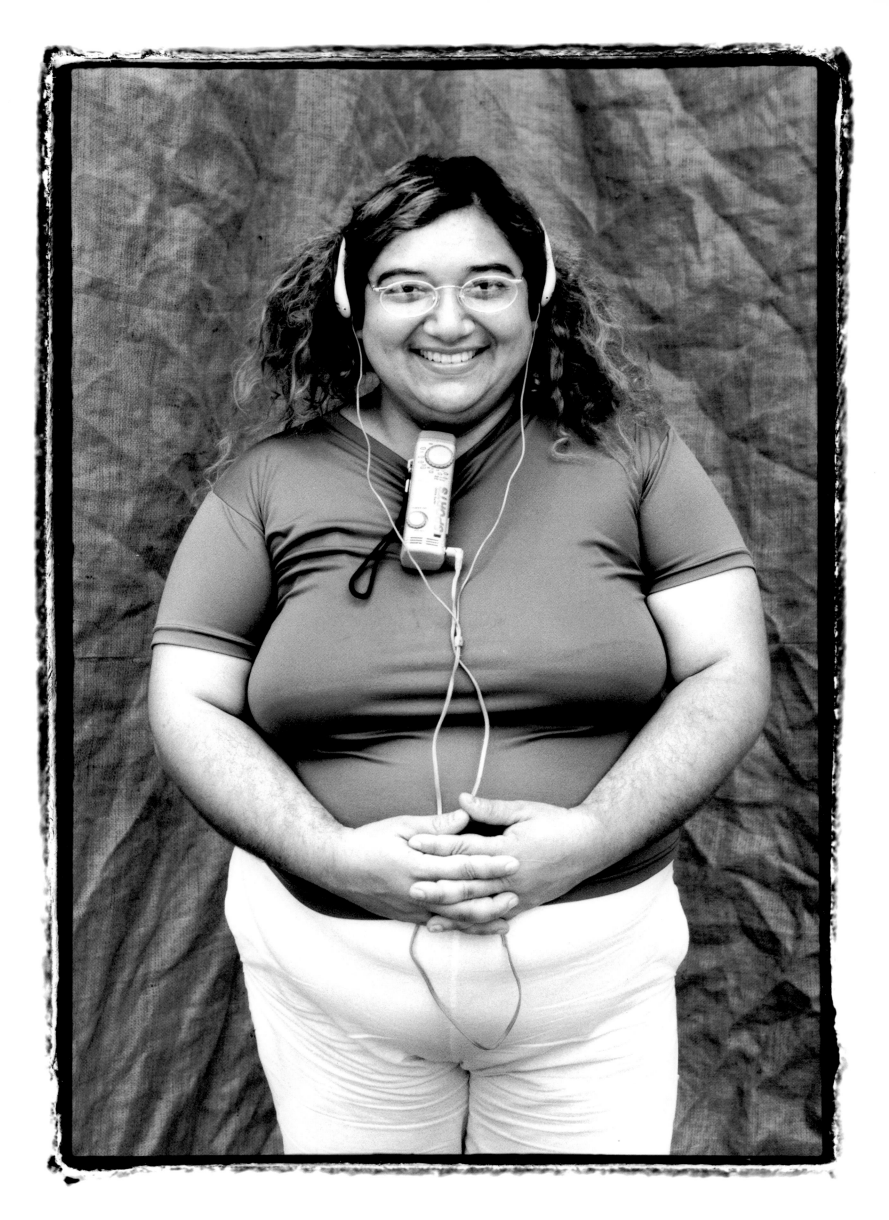

Nearly
15%
of the
homeless men
in New York City
are veterans
of the U.S.
Armed Forces.

Ronald, summer 1999

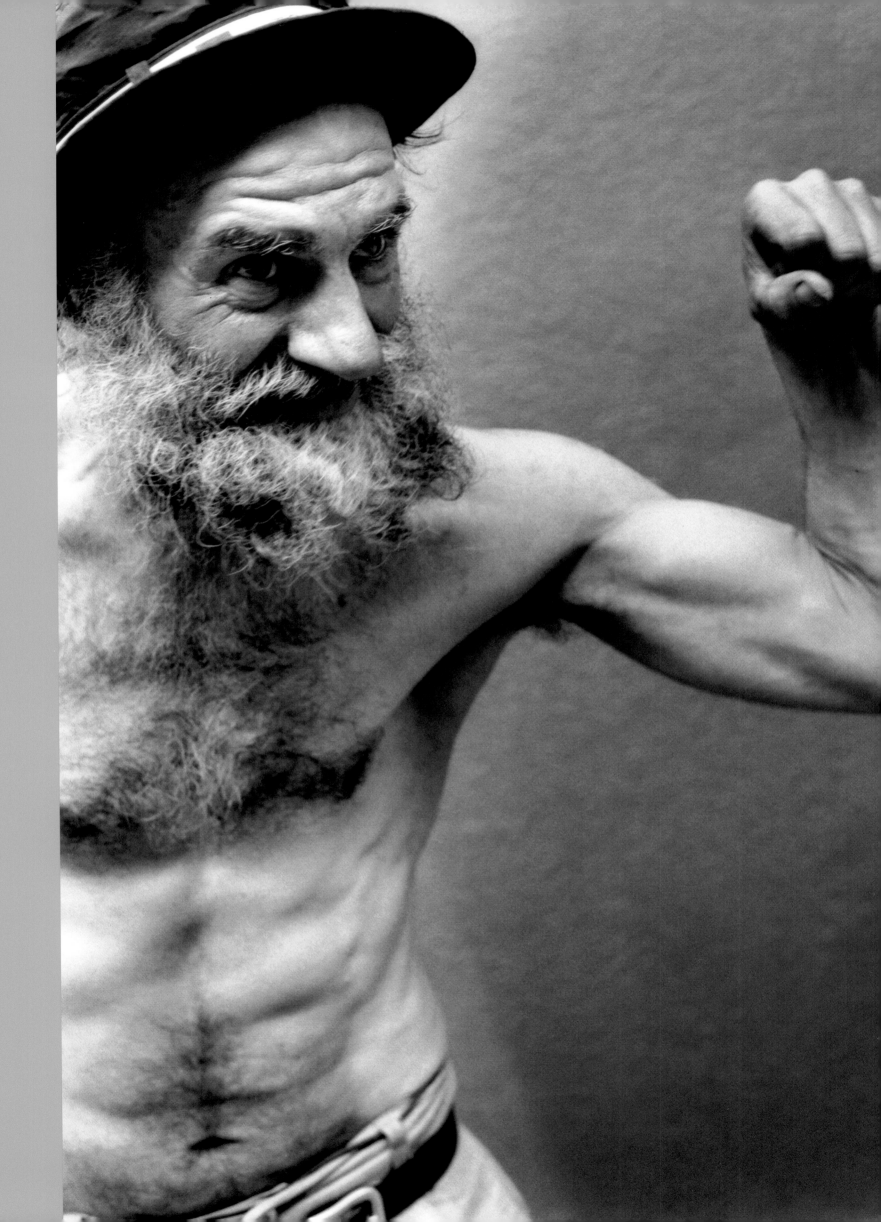

Tomas

Tomas is a forty-five-year-old Puerto Rican, and a Vietnam Veteran.

In 1976 he was a bronze medalist in boxing, welterweight division. Then he moved to New York with hopes of greater success and happiness. When he arrived in the Big Apple, he first worked as a trainer in several gyms, then as a security guard at the Guggenheim Museum. His last job was doing phone surveys for a veteran's organization. He was fired from each and every job. Discouraged, he turned to alcohol, an addiction which caused his being imprisoned for a bar fight.

Upon his release from prison, there was no other refuge for him but the street.

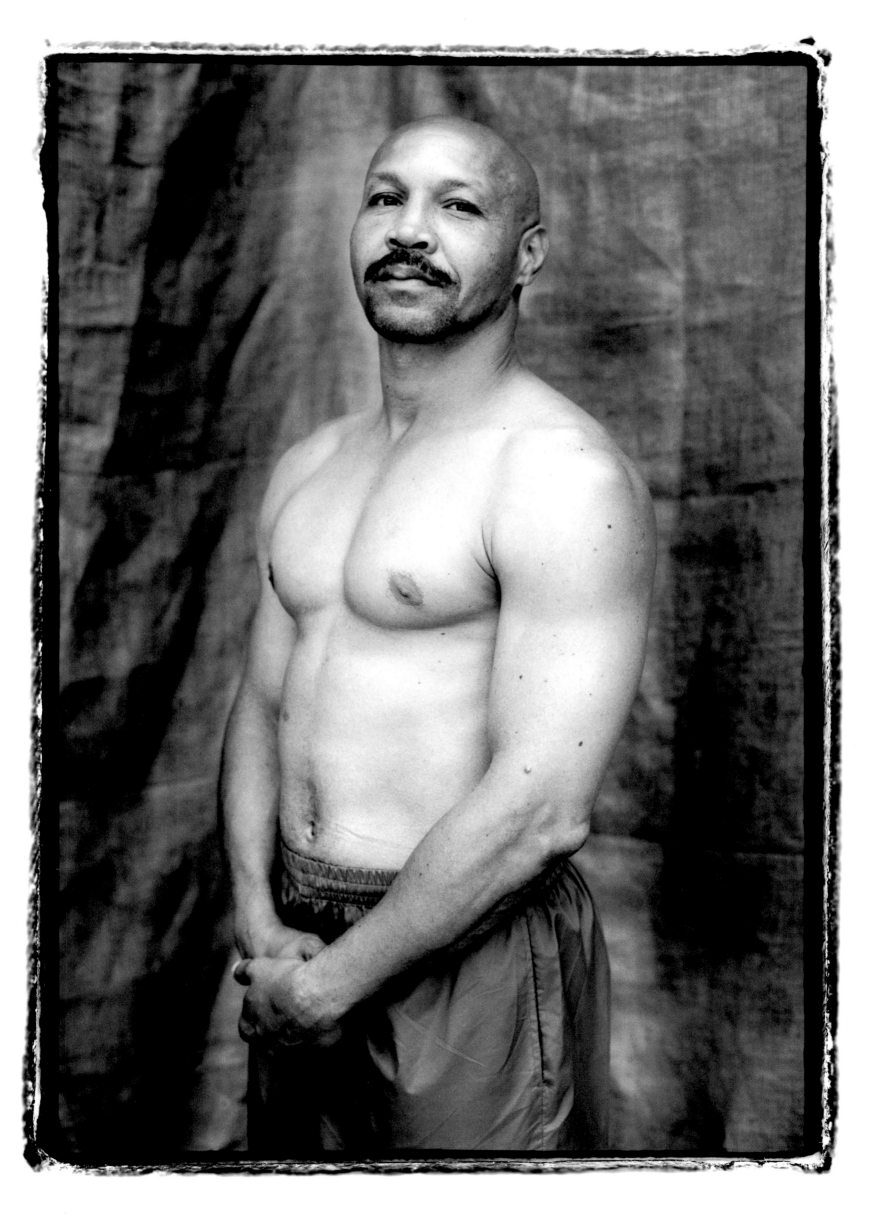

...and Koko

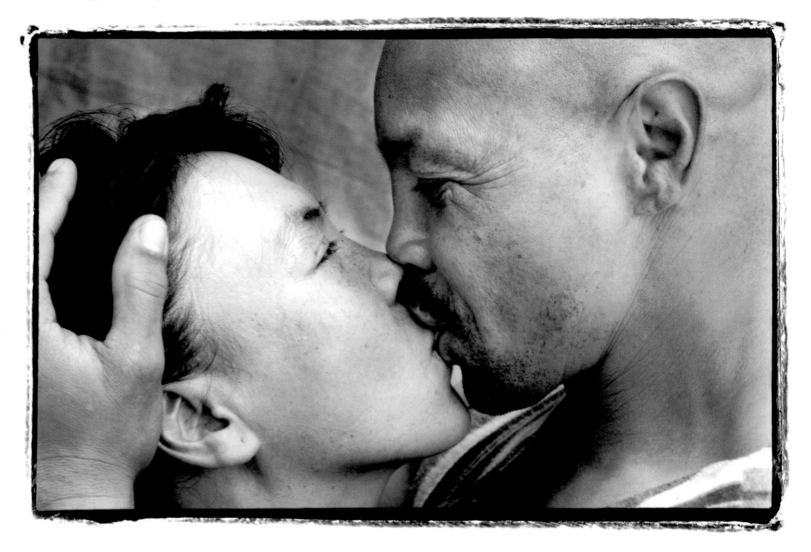

But in Tomas' search for a place to stay, he found something else: a loving companion at the St. Agnes shelter. Her name is Koko; she is Korean, and, like Tomas, a recovering alcoholic.

It was love at first sight. But being together meant that they would have to leave their same-sex dorms at St. Agnes. So they decided to live together under the bridges of the East River in a makeshift cardboard home they assembled each night and disassembled each morning. They frequented the Holy Apostles Soup Kitchen for a long time; but gradually they came by less and less. Apparently the power of love and a profound desire for a better life gave them the spark and the strength they needed.

Koko and Tomas have been sober for over two years now. Tomas has a permanent part-time job to support their life together in a minuscule studio apartment in Queens, sufficient enough for two people who love each other. A lot.

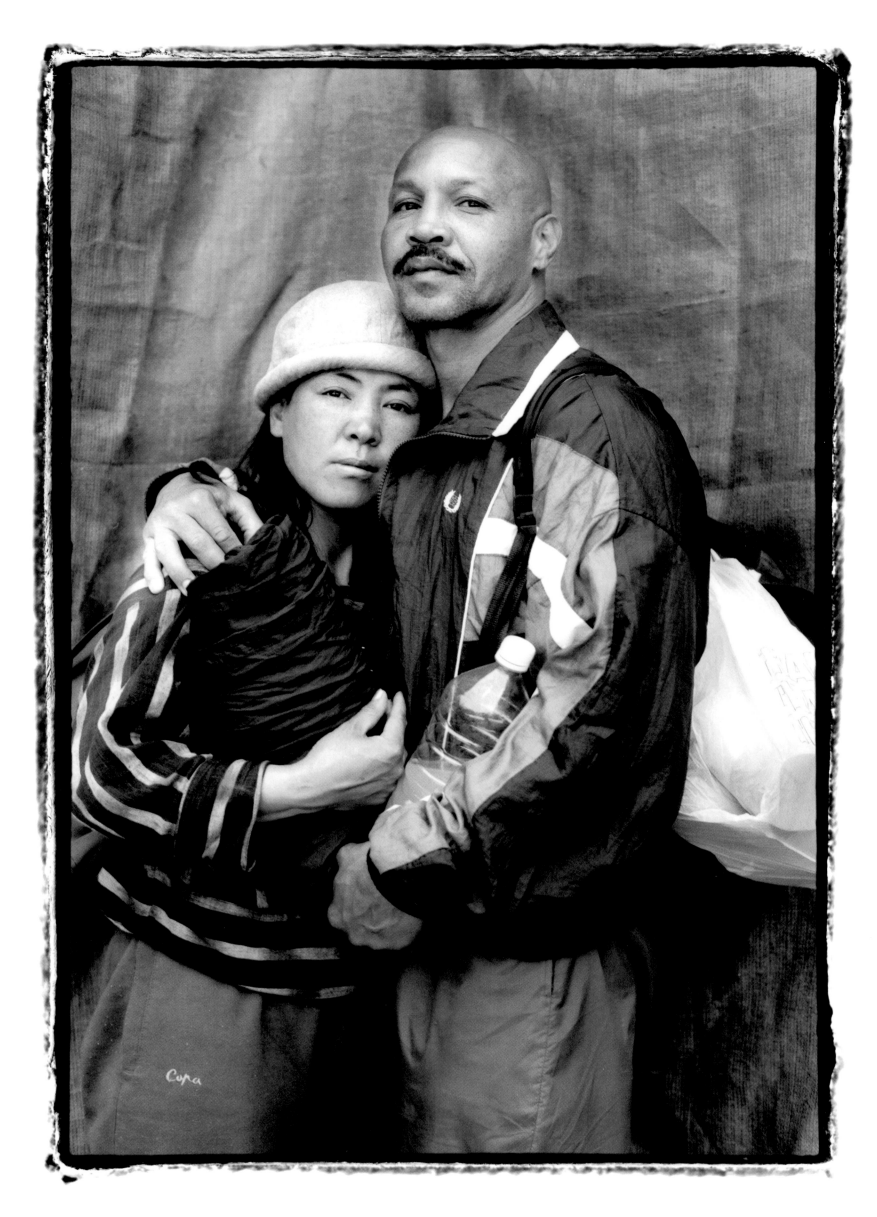

Kathy

Kathy approached me to ask if I would take her portrait. She had the most elegant dress, and a plastic pose like a warrior woman with her head raised high, eyes glued to the lens. Without fear. "Now you can shoot," she instructed me.

She was born and raised in New York, the daughter of an Irish mother and a Jamaican father. She started her struggle with life at the age of six, when a hit-and-run accident with a bus left her paralyzed from the neck down. Six years of intense physical therapy enabled Kathy to walk again. At the age of fifteen she started her studies in classical dance, fulfilling her dream and ambition of being a ballerina. Between the ages of eighteen and twenty, she worked as a model and attended college, where she fell deeply in love. The relationship lasted for seven years, with plans for a wedding, when one day an ugly argument drove her boyfriend away, slamming the door behind him. He got into a cab, Kathy still calling after him to come back. He made it two blocks before getting hit by another car, an accident that killed him immediately.

Kathy is alone, oppressed by a terrible feeling of guilt. Once again paralyzed, this time by the pain of existence, she lost the ability to communicate, and to work. She started to live on welfare, receiving not just one check, but seven. This lasted for several months, until Kathy was caught, sentenced to six months of jail time. When she got out, she had nothing.

Kathy has been homeless for five years now, but she doesn't give up. She eats and sleeps where possible, faithfully waiting for the day when she can hang her framed portrait on the wall of her new living room, and tell her friends the story of "when Kathy was homeless."

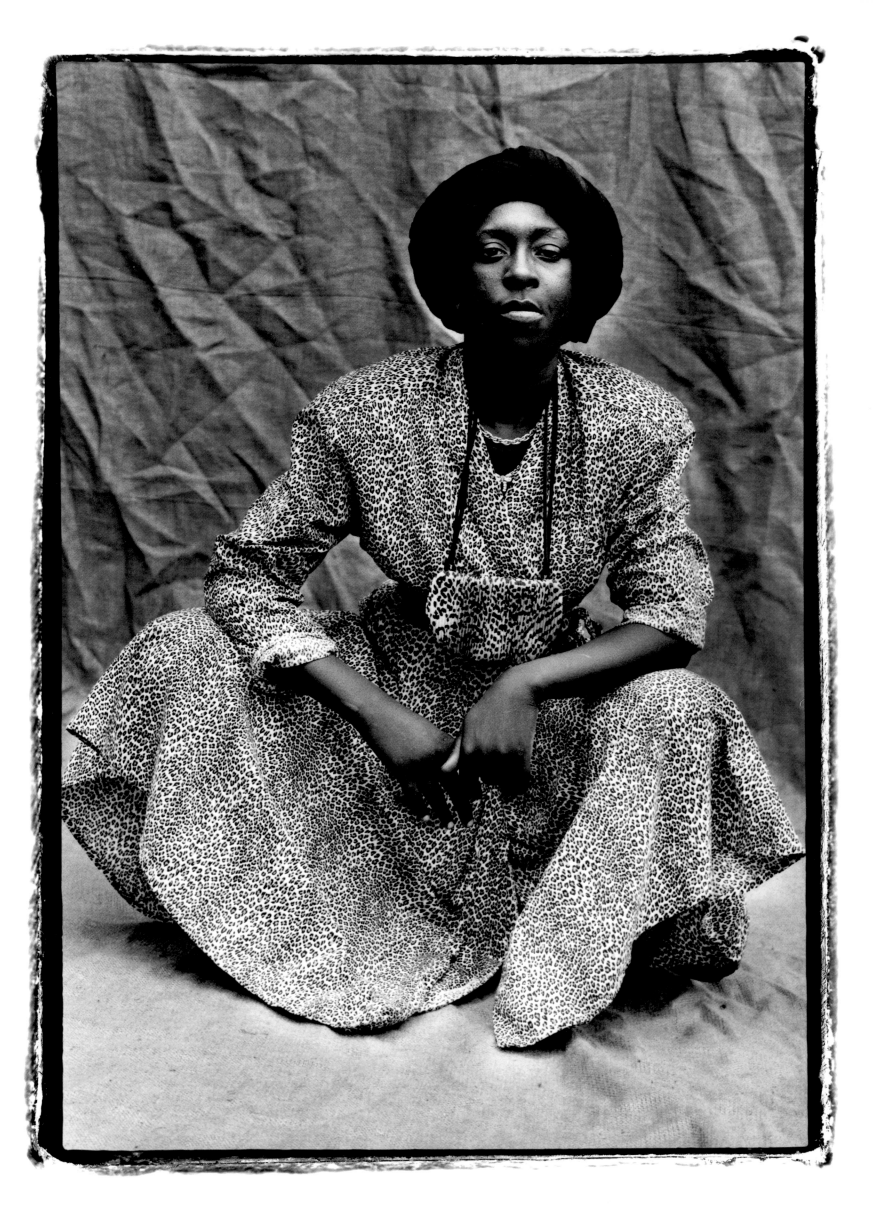

Ernest and Donald

A homeless life in New York requires terrific savvy. These two best friends take pains to keep themselves informed about the new laws concerning the needy of the city—the opening of new shelters, where to get clothes and medical care, new part-time or temporary jobs available. They live on very little, a few bucks from odd jobs here and there, but together they approach life with sincere practicality. The friendship that binds them has become their foundation of a home.

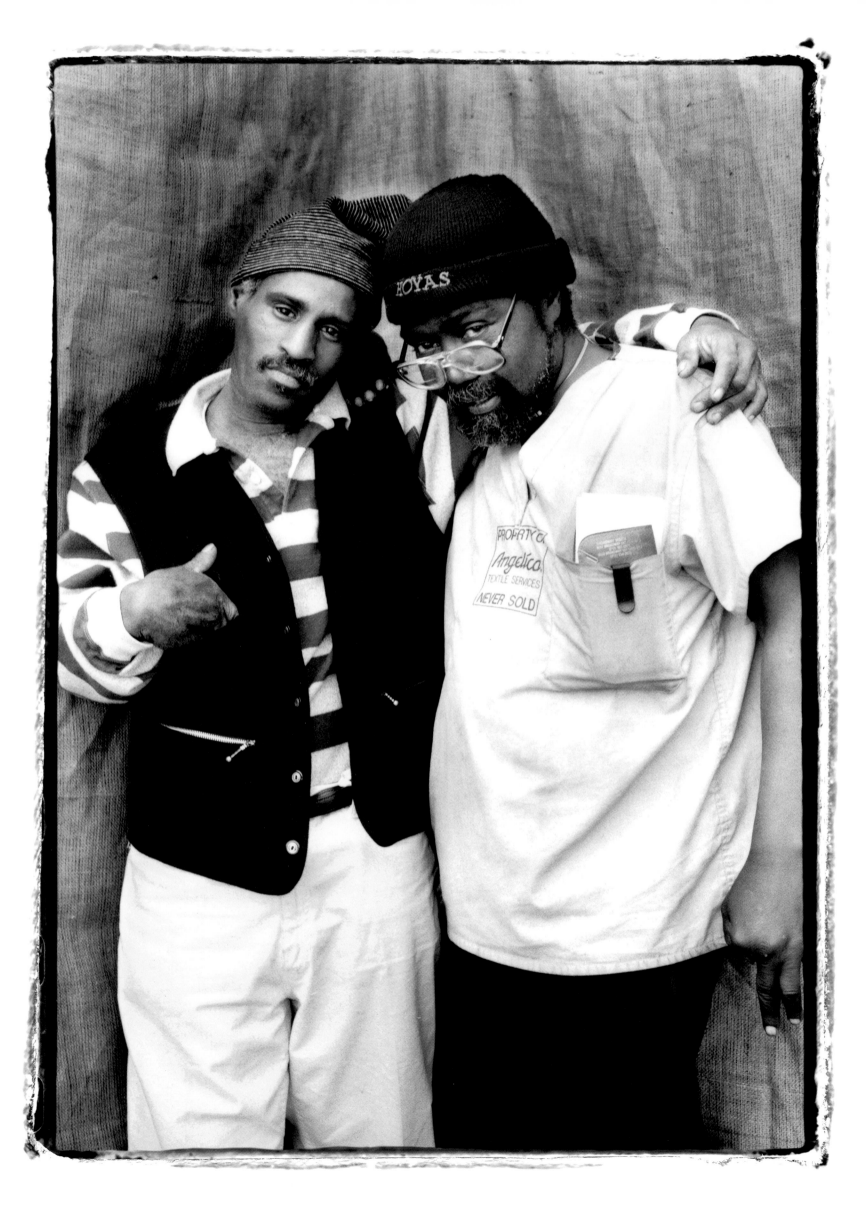

From 1975 to 1999,
the real median rent
(adjusted for inflation)
for an apartment
in New York City
increased by nearly
33%.
Over the same period,
the real median income
for renter households
in New York City
increased by only
3%.

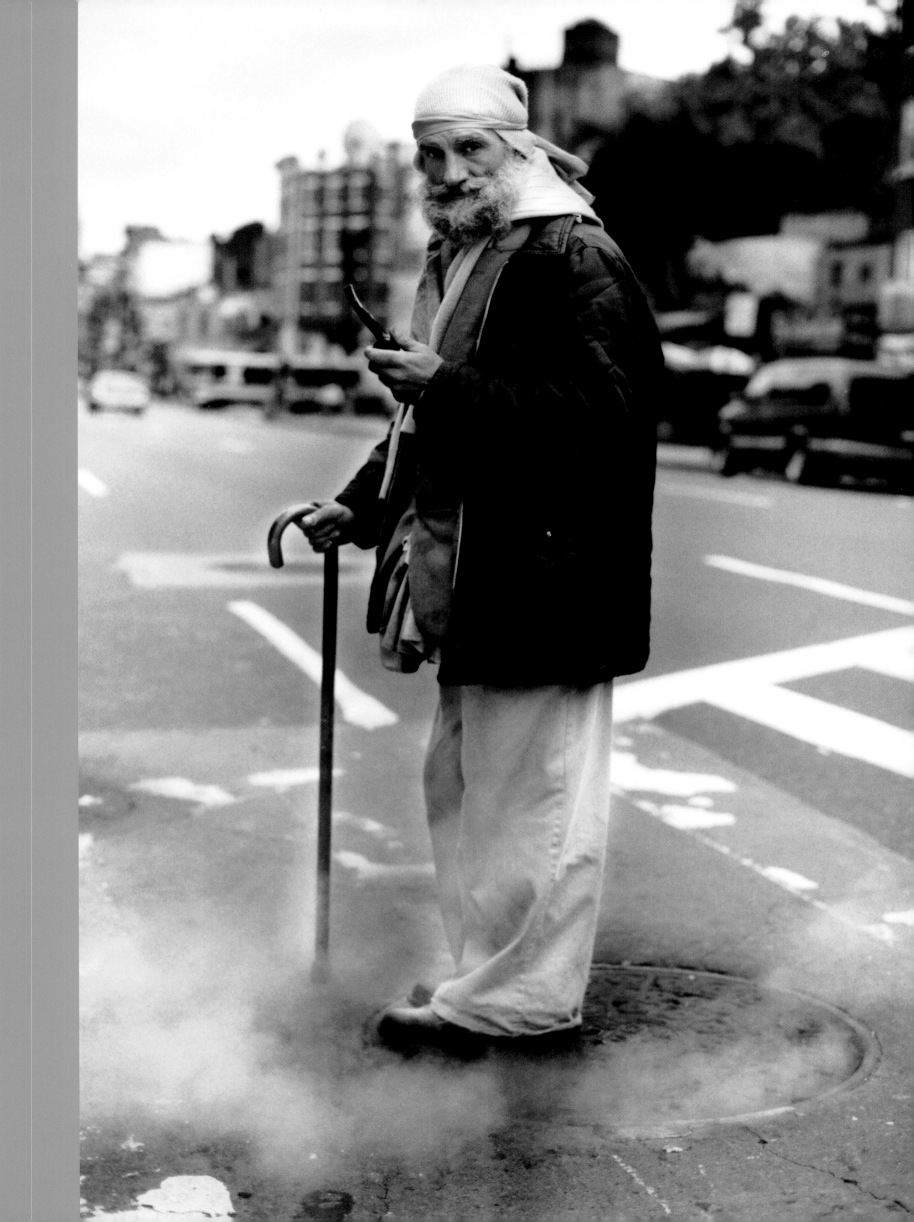

Christina (as Gary)

His name is Gary Thomas. He is twenty years old and comes from Beeville, Texas. On his fifteenth birthday, his mother treated Gary and his five siblings to a trip to New York. Gary picked out his best dress, and applied mascara to his eyelashes. Once they were among the skyscrapers of the Big Apple, his mother whispered in his ear that maybe it was better if he stayed here: "Don't come back to Texas, Gary; you don't set a good example for your brothers and sisters." Gary didn't go back.

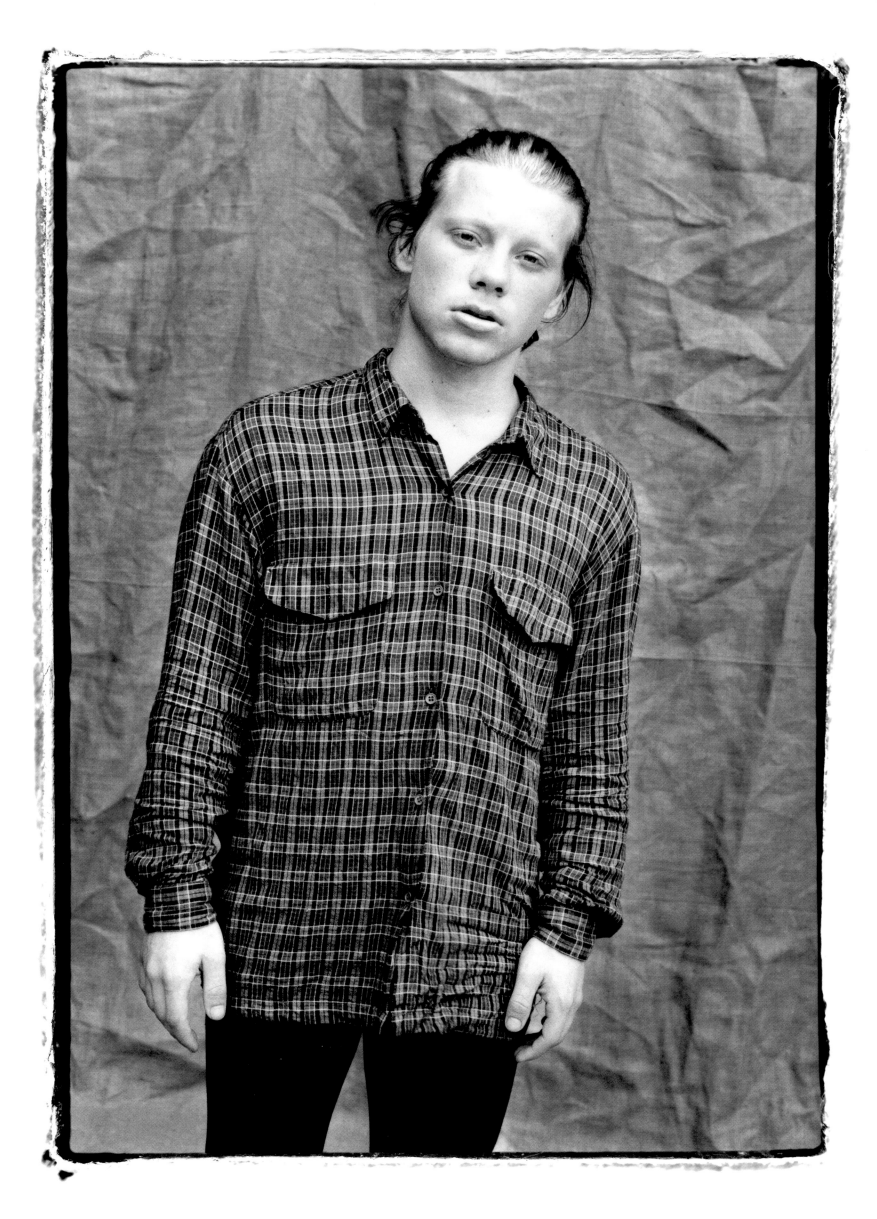

Christina (as Christina)

In New York, Gary became Christina. She developed a drug habit. To survive, she was forced to prostitute herself. Sometimes she was jailed for petty crimes. In 1998 she was diagnosed with HIV.

One part of her feels she is a woman; the other part feels he is a man. People look at her and see a man, and they expect her to act like one.

When Christina looks at herself in the mirror, the reflection she sees is her mother, a mother she no longer loves. She blames her mother for abandoning her, and for never having understood her. Christina feels that her mother is responsible for her insatiable desire for love. As Christina traces her profile in the mirror with a finger, she waits for someone to take her hand and say "I love you."

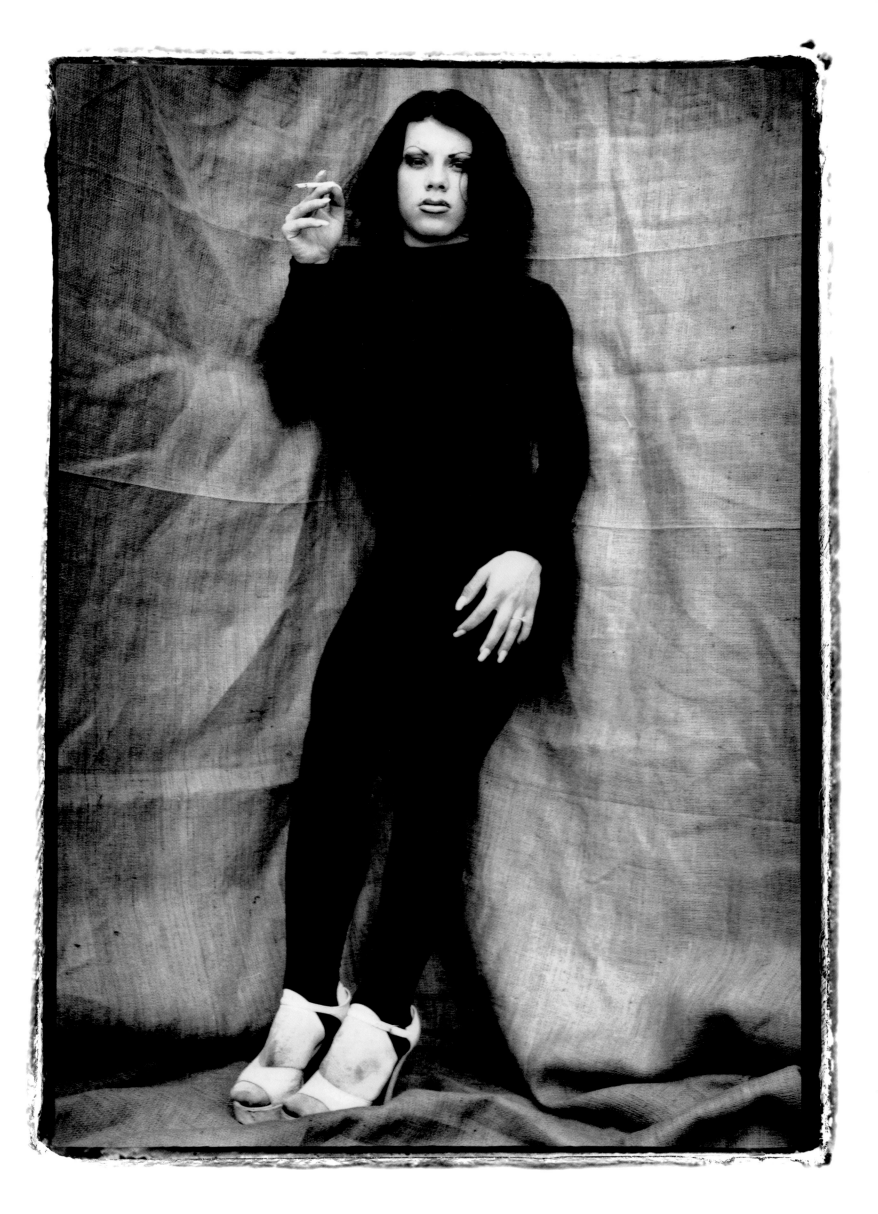

Lawrence

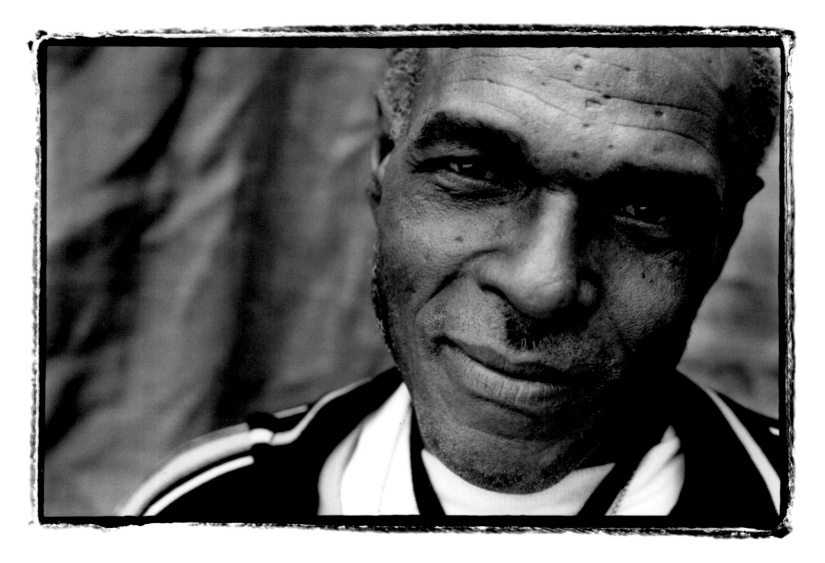

Maybe it's because Lawrence and I share the same birth date that made the friendship between us so special.

He is creative, extroverted, and genial, and creates magic with his percussive virtuosity. He sleeps in The Waiting Park opposite the Soup Kitchen; and every week appears with a "new" outfit made of clothes he finds in the trash. Lawrence has had many names and many lives. He was born in Trinidad fifty years ago. In that many years, lots of things can change: names, places, lives. People can change with the same frequency as Lawrence's inspired outfits.

Although Lawrence can be found around the Soup Kitchen every day, he doesn't eat there because he dislikes the lines. Even so, he's known as "King of The Waiting Park" for the way he rules the park, making sure "everything's cool."

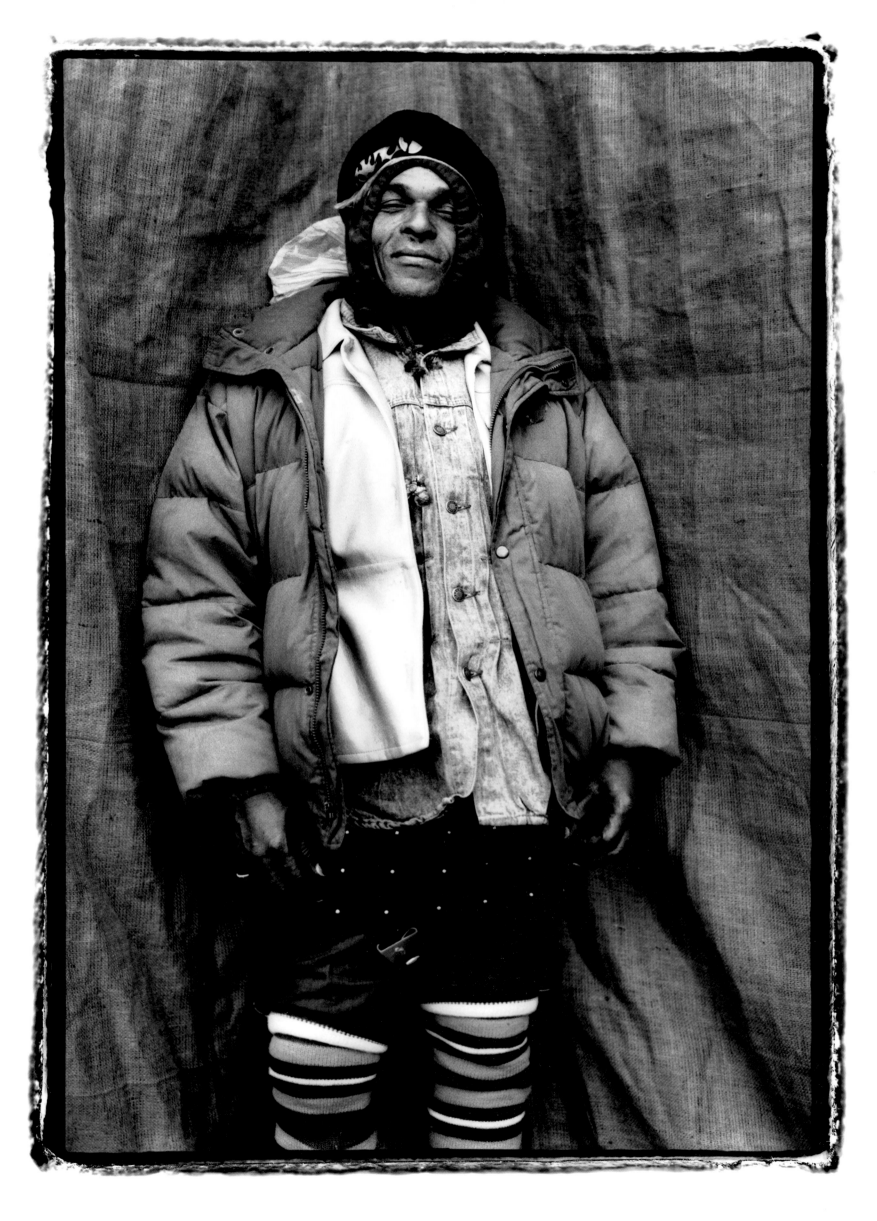

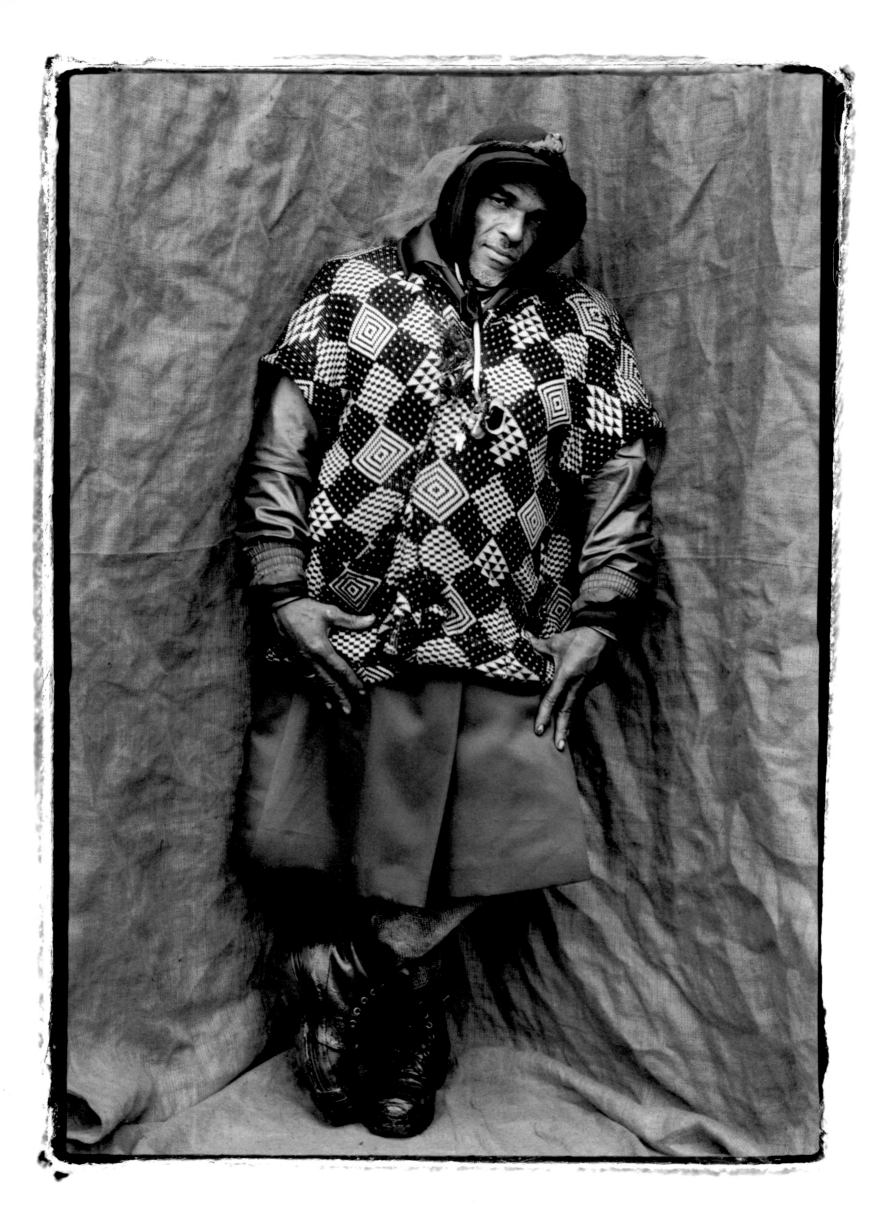

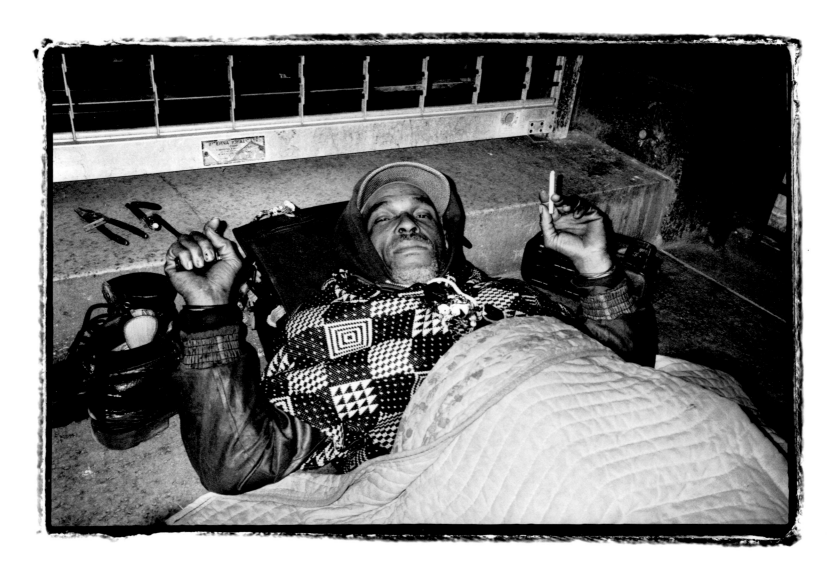

Almost daily, out of the blue, Lawrence will open his case, the treasure chest that he is never without, and produce a book, a clipping, or a newspaper. He will then read aloud what seems to be a random sentence, only to look me in the eyes and declare, "You see? I told ya!", and transforming in the process a simple declaration into either something directly relevant to the moment or a premonition of the near future.

Maybe it's because Lawrence is also a magician.

Between 1990 and 2000,
the average shelter stay
for a homeless family
with children in New York City
increased from
5 months
to
10 months.

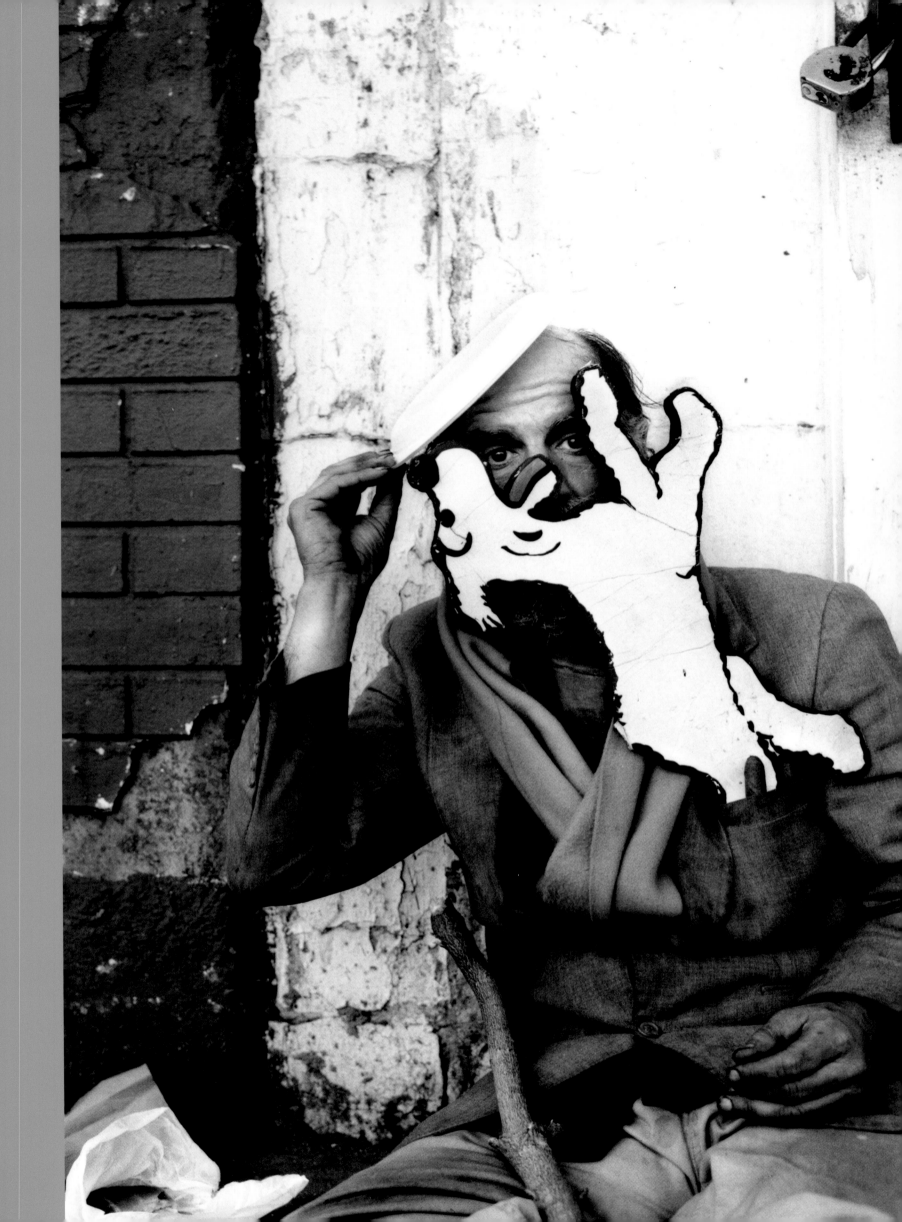

Robert

Robert is a loner, but not an angry or disappointed one. Robert is a loner who smiles under his speckled black-and-white beard, and whose eyes convey his immense desire for love.

Out of the blue he asked me if he could participate in my project. Everything he owns—his face and intense smile—is in this picture, his gift to us.

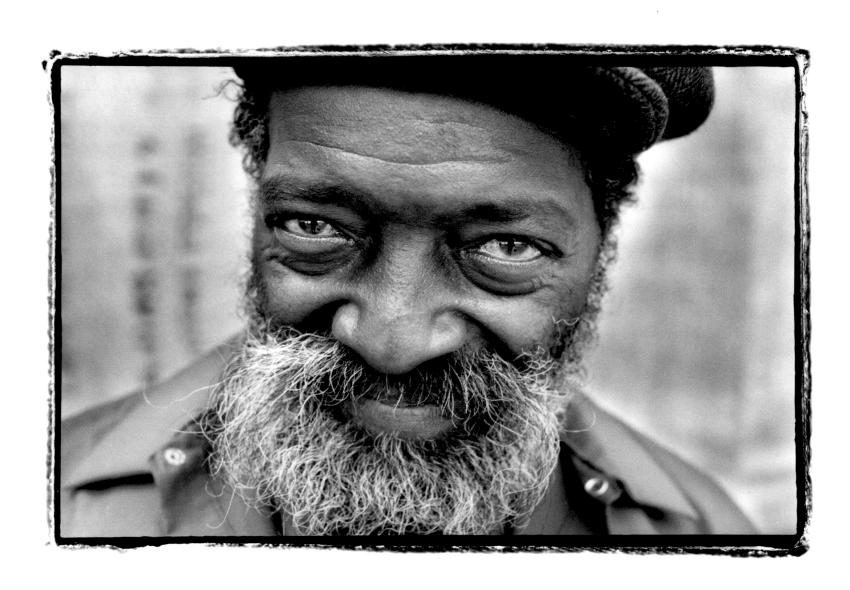

Miles

Miles has always been told that he looks like Ronald Reagan, but the resemblance to that famous face wasn't enough to keep him from losing his mobility, his home, and his serenity, one after the other.

After the car accident, Miles was confined to a wheelchair. He had expected the insurance company to start helping him immediately, but they didn't. He's been waiting for help for seven years. In order to cover the costs for several surgical operations, the medication, and physical therapy, he had to sell all of his belongings, one after the other. Now Miles' only belongings are his wheelchair. And his face.

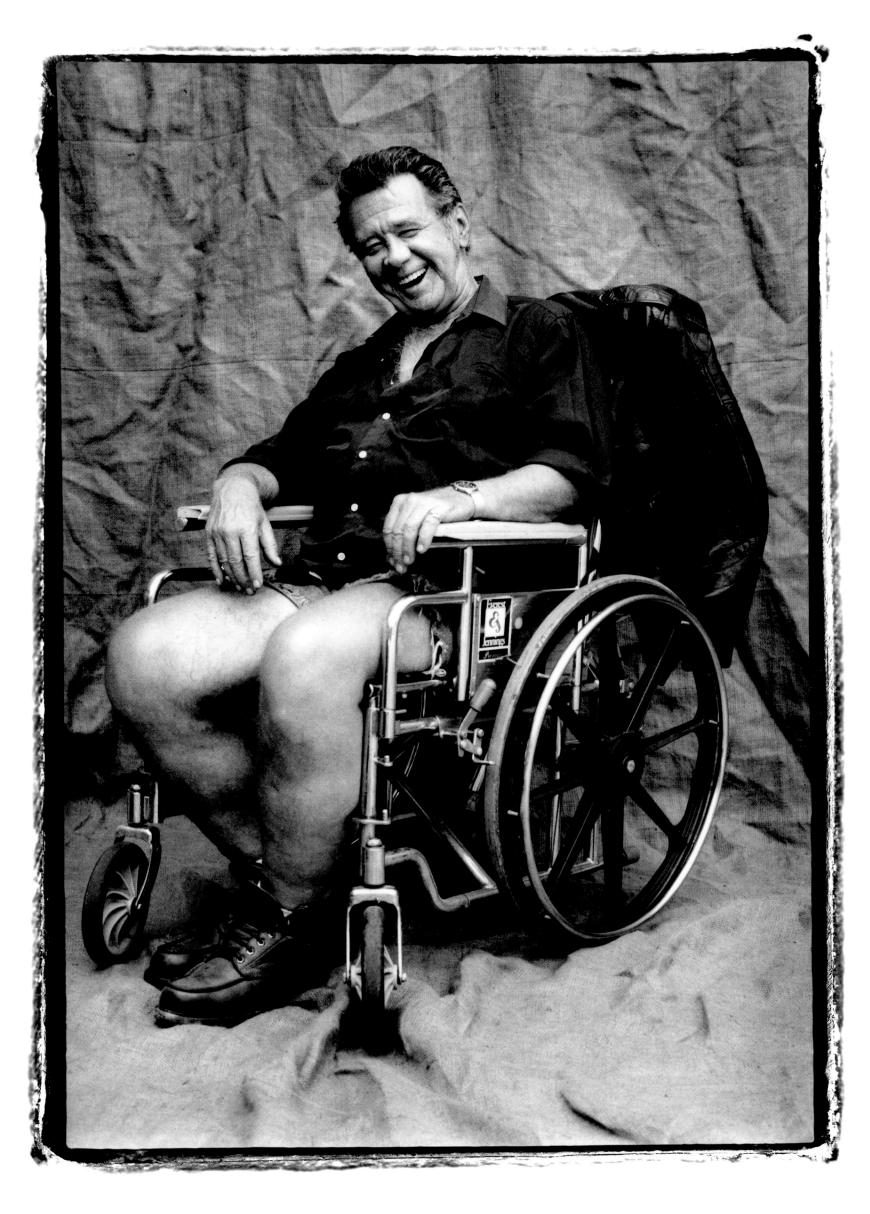

Glenn

Glenn is a "direct woman," she doesn't like shades of gray—for her it's either black or white. This could be a product of the Guatemalan blood running in her veins, but more likely it's because she lives on the streets of New York, where "being direct" is a necessary tool for survival.

Glenn saw other people having their picture taken in my "outdoor studio," and decided she wanted to pose for a snap. Only one. This one. Direct.

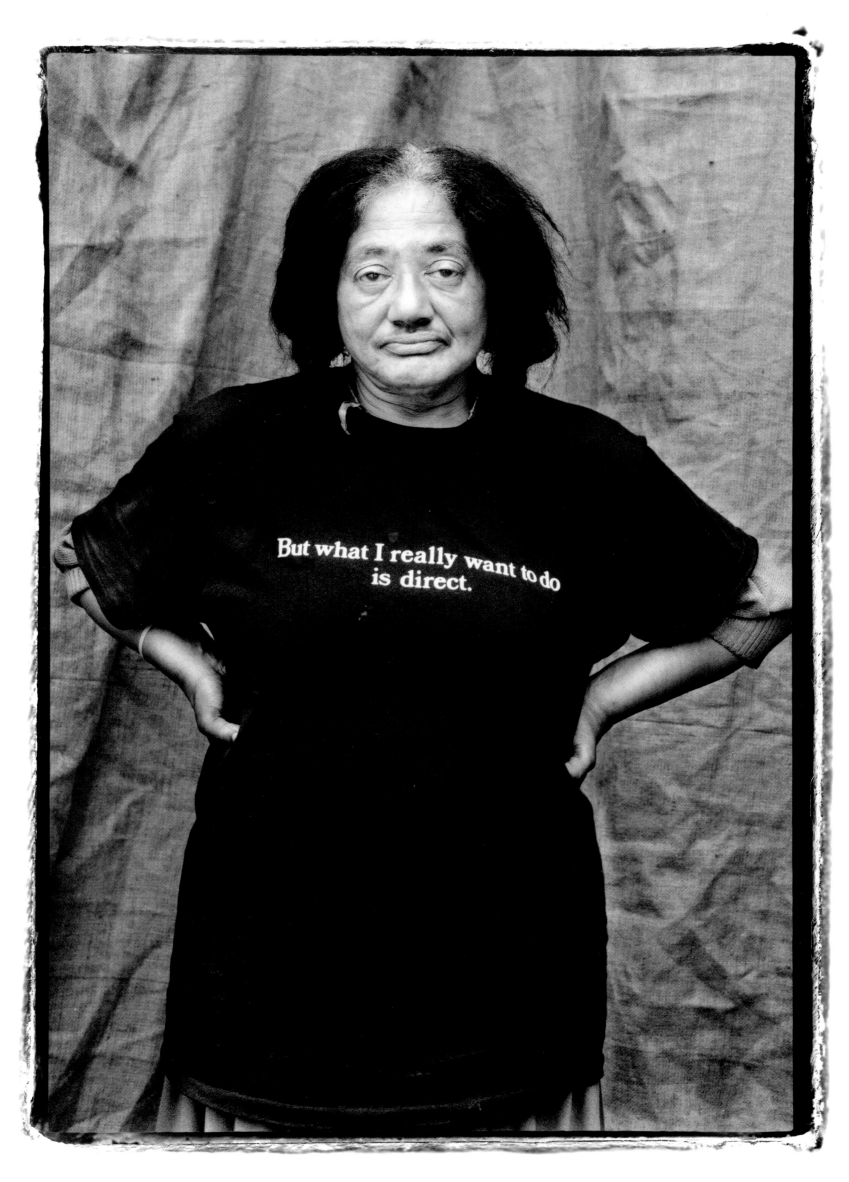

Frederick

Frederick was sleeping on a bench in The Waiting Park, close to the area where I was shooting. One of the many street noises woke him up. He came over, and watched me take photographs of the others in my "outdoor studio"—a found burlap backdrop nailed to a corner of the school building next to the park. Inquisitively, he came closer, and posed spontaneously, providing us with the memory of a single photo, and then disappeared. In silence.

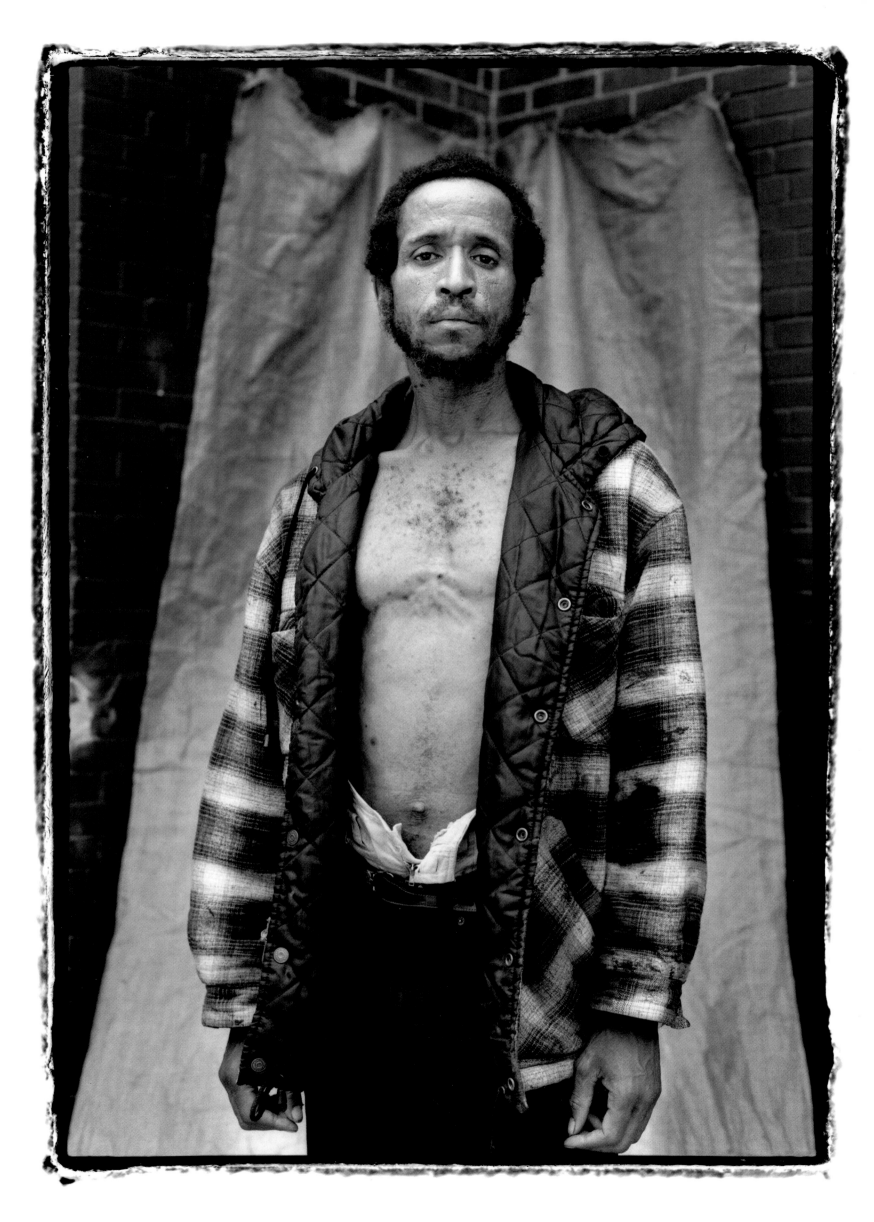

Nearly **100,000** men, women, and children experience

1990 and 2000, the **average shelter stay** for a homeless

• About **15%** of the homeless men in New York City are

New Yorkers are **black or Latino**, although only half of New

City, **70%** of homeless people residing in the municipal

• Over a recent 9 year period (1987–1995), more than **333,000**

the municipal shelter system—representing nearly **1** of every

New York City **lost over 500,000** apartments with monthly

half of all the affordable apartments **(-52.2%)**.[7] • From

homeless New Yorkers residing each night in homeless

2000, the City of New York **reduced the number of new**

individuals by **75%**.[9] • From 1975 to 1999, the **real median**

increased by nearly **33%**. Over the same period, the

York City increased by only **3%**.[10] • In New York, the

year, the cost of a **prison cell** is **$60,000** per year and the

year. In comparison, the cost of a **supportive housing**

1. Coalition for the Homeless, 2001 shelter survey. **2.** New York City Human Resources Administration, shelter census reports (1990); New York City Department of Homeless Services, shelter census reports (2000). **3.** New York City Department of Homeless Services, shelter census reports, 1999. **4.** Dennie P. Culhane, Edmund P. Dejaowski, Julie Ibanez, Elizabeth Needham, and Irene Macchia, "Public Shelter Admission Rates in Philadelphia and New York City: The Implication of Turnover for Sheltered Population Counts," in *Housing Policy Debate* (Volume 5, No. 2, 1998, 107–140). **5.** New York City Department of Homeless Services, shelter census reports, 2000. **6.** Dennis P. Culhane, Stephen Metraux, and Susan M. Wachter, "Homelessness and Public Shelter Provision in New York City," *Housing and Community Development in New York City: Facing the Future*, ed. Michael Schill (SUNY Press, 1999) 203-232. **7.** United States Department of Commerce, Bureau of the Census, Housing and Vacancy Survey (1991 and 1999) **8.** New York City Human Resources

homelessness annually in New York City.[1] • Between family with children increased from **5** months to **10** months.[2] **veterans** of the U.S. armed forces.[3] • Nearly **90%** of homeless York City's population is black or Latino.[4] • In New York shelter system are **parents and children in families**.[5] different homeless men, women, and children resided in **20** New York City residents **(4.6%)**.[6] • From 1991 to 1999, rents under $500, representing the loss of more than the early 1980s to the year 2000, **the number of shelters** increased by more than **75%**.[8] • From 1994 to **apartments** produced for homeless families and **rent** (adjusted for inflation) for an apartment in New York **real median income** for renter households in New cost of a **psychiatric hospital bed** is **$113,000** per cost of a **shelter cot** for an individual is **$23,000** per **apartment** with on-site services is **$12,500** per year.[11]

Administration, shelter census reports (1982–1994); New York City Department of Homeless Services, shelter census reports (1994–2000). **9.** City of New York, Office of the Mayor, Mayor's Management Report (CFY 1994–CFY 2000). **10.** United States Department of Commerce, Bureau of the Census, Housing and Vacancy Survey (1975 and 1999). Inflation adjustments by Coalition for the Homeless (2000). **11.** Corporation for Supportive Housing, New York/New York Housing for Homeless Mentally Ill Individuals: 1999–2000 (Corporation for Supportive Housing, February 2000) Statistics on the page opposite "Ronald, winter 1998/Why Discriminate". **12.** Corporation for Supportive Housing, New York/New York Housing for Homeless Mentally Ill Individuals: 1999–2000 (Corporation for Supportive Housing, February 2000). **13.** Coalition for the Homeless, shelter surveys (2000). **14.** The Holy Apostles Soup Kitchen.

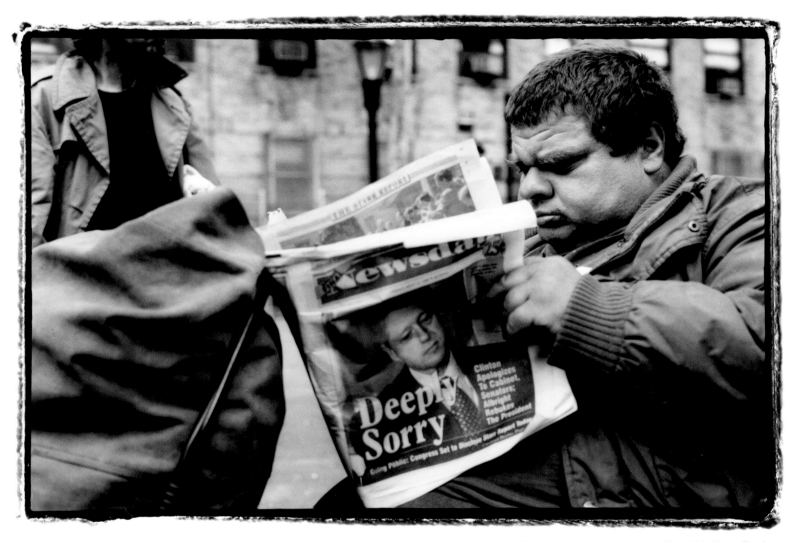

Steven reading the newspaper in The Waiting Park

On any given day in New York City
between
30% and 50%
of homeless single adults
in shelters
have a chronic mental illness;
20%
of the homeless individuals are employed
full-time or part-time;
60%
of the guests who eat at a
soup kitchen
would accept a paying job
the same day.

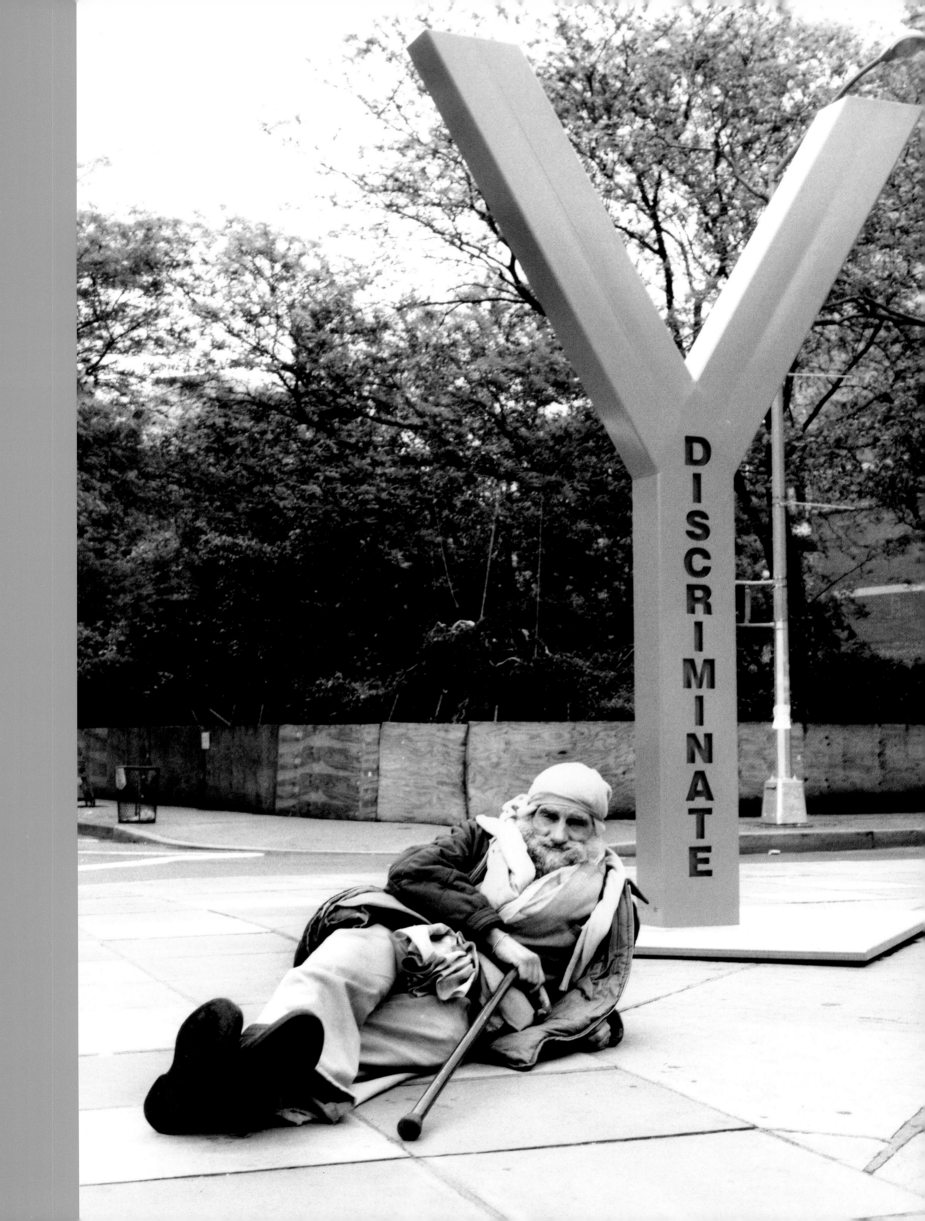

Afterword

As modern homelessness enters its third decade, homeless Americans have become a tragically commonplace part of urban life, and yet seem invisible. Pushed to the margins of cities, ignored by the media and elected officials, homeless people are all too often forgotten by their neighbors. Invisibility may be, strangely enough, the most damaging affliction facing our homeless neighbors.

Invisibility breeds myths and stereotypes. Today, more than a generation after the modern homelessness crisis emerged, even sophisticated urbanites still harbor the mistaken belief that most homeless people are older men, alcoholics and drug addicts, panhandlers and street dwellers. In fact, a wealth of public data and academic studies reveal a startling fact: The person most likely to experience homelessness in New York City is an African-American or Latino child. Moreover, homelessness is an alarmingly commonplace occurrence, particularly for low-income families and individuals. One landmark academic study found that one of twenty New York City residents experienced homelessness over a nine-year period, and similar national studies have echoed these findings for other cities.

Invisibility breeds amnesia. Far too many Americans have forgotten that, for most of the last century, homelessness was not a widespread phenomenon. Indeed, only during the Great Depression and since the late 1970s has there been mass homelessness in the United States, and it was caused largely by identifiable—and reversible—government cutbacks in housing assistance and changes in mental health and welfare policies. Today there is a generation of Americans who have grown up in a country where homelessness is an everyday part of urban life, who don't recall a different America.

Invisibility breeds complacency and hopelessness. As many Americans have grown resigned to the presence of homelessness, there has emerged a growing sense of despair that nothing can be done to solve the problem. Contributing to this false sense of hopelessness, conservative commentators and "think tanks" have for much of the past decade propagated a "blame the victim" message that has diverted public discourse away from the real causes of homelessness, and the real solutions. Sadly, the sense of shock and outrage

that most Americans experienced in the early 1980s, upon first encountering people sleeping on sidewalks, in parks or in train stations, has morphed to a sense of fatigue and despair. Far too many people have thrown up their hands, resigned to stepping over prone bodies on the street, to tales of mothers and children crowded into shelters and welfare hotels.

Effective, proven solutions, however, exist in abundance. Indeed, we have learned that investments in affordable housing, in supportive housing for people living with mental illness and AIDS, and in rental assistance can dramatically reduce homelessness. Moreover, many of these solutions are actually cheaper than emergency shelter and other institutional care. And other common-sense measures, like providing safe emergency shelter for all who need it, can be put in place swiftly. We have the tools at our disposal. All that is lacking is the public will to move forward with long-term solutions to modern homelessness.

Remarkably, during the longest economic expansion in American history, homelessness is on the rise nationwide. In New York City, there were more homeless adults and children sleeping in shelters in 2001 than at any point since the late 1980s. Cities as diverse as Cleveland, San Antonio, and New Orleans report rising numbers of families and individuals crowding shelters and soup kitchens. But even amidst the signs of a re-emerging homelessness crisis, there is little discussion of the continuing plight of homeless Americans. And public officials seem intent on continuing with the failed policies of the past, like the paltry investments in housing and shortsighted reductions in vital benefits. Once again, the homeless threaten to remain invisible.

Salvo Galano's remarkable, moving photographs cut through the stereotypes, the hopelessness, the collective amnesia about our homeless neighbors. They make us look, make us really see these courageous, struggling individuals—not as statistics, not as myths. These incredible portraits are an invaluable reminder that homelessness persists in the United States as a scandalous, tragic, and solvable problem afflicting hundreds of thousands of Americans every year. In short, these photos make the homeless visible.

Patrick Markee, May 2001
Senior Policy Analyst, Coalition For The Homeless

Acknowledgements

During this long project I was extremely fortunate to have, and to have met, many special friends who believed in the message contained in these pages, and who shared it with me. Their help and moral support was absolutely fundamental to the realization of this book.

First of all, I would like to thank my father Antonio for his unconditional love, and my mother Rita (may she rest in peace) for her always present and invisible guidance.

I would like to thank everyone at the Holy Apostles Soup Kitchen: The Reverend William Greenlaw, The Reverend Elizabeth Maxwell, Clyde Kuemmerle, Neville Hughes, all of the personnel and volunteers for always making me feel welcome, and in particular, all of the guests who passed through the lens of my camera—for their friendship, faith in me, and for sharing extremely personal moments of their lives.

I am especially grateful to my dear friends at the John Simon Guggenheim Memorial Foundation for their artistic sensibility, especially Joel Conarroe, Thomas Tanselle, and Richard Hatter. Thank you for the fellowship I received in 1998, which allowed me to suspend my commercial work to complete this project

Special thanks to:
Fiammetta Bonazzi, Corrina Hill, Ronnen Amir, Clyde and Lucy Kuemmerle, Joel Conarroe, and Cara Maniaci who, with great patience, helped me in composing, translating, and assembling the text;
Patrick Markee, Senior Policy Analyst of the Coalition for the Homeless, and Judith Walker, Executive Director of the New York City Coalition Against Hunger, for donating their precious time in helping me finding and editing the statistics in the book;
Jeff Bridges, and again to Patrick Markee, for their invaluable support and for their insightful, and wonderfully written texts for this book;
Three amazing people and good friends—my "guardian angels" in New York—Margie Oliver, and Lauren and Lenny Stern, for donating so much of their time to managing this project while I was away, and for helping me with everything;
My dear friends Ivano Grasso, who took my portrait with Ronald in the "outdoor studio," Matteo Bologna, who contributed his innovative art direction, and Bruno Frontino, who lent me his precious darkroom until the last print was made;
My publisher Daniel Power and his wife-now-colleague Susanne König, for finding me when I was "lost" and bringing me back to what I love doing, and everyone else at powerHouse—Craig Cohen, Cara Maniaci, Sara Rosen, Kristian Orozco, and Kiki Bauer—for their continuous support;
My friend, designer Yuko Uchikawa for the superb finishing touches on the maquette of the book;
Francesca and Mario Peliti, my Italian publishers, for doing this book in my native country;
And Andrew Wylie, for being the best agent in the world.

The following people have helped this book along in various ways: Grazia Amorese, Silvia Armari, Hiuwai Chu, Mauro Catenacci, Grazia D'Annunzio, Roberto DeVicq, Franark, Rom and Jen Gabrielli, Gianemilio Mazzoleni, Mark Meyer and Nikolina Dosen, Anna Montalbetti, John Louis Petitbon, Luisa Pronzato, Lynda Richardson, Lyle Stuart, Edwin Tan, and Roberta Valtorta.

To all of those whom I have not mentioned, thank you for being my friend.

I love you all,

Salvo

For more information about the volunteers program at the Holy Apostles Soup Kitchen, or if you would like to help their mission with a contribution, visit **www.holyapostlesnyc.org**

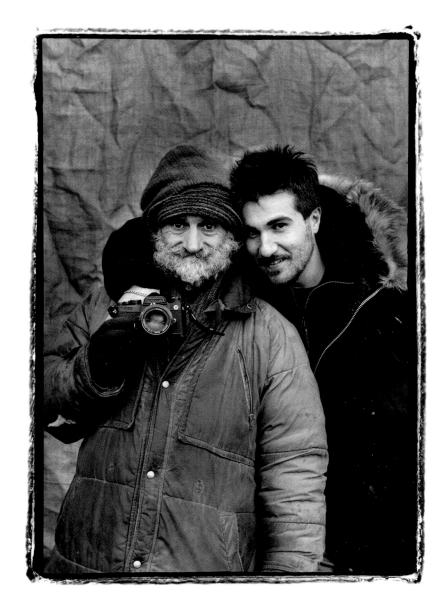

Salvo Galano

Born in Milan, Galano was just fourteen years old when he developed his interest in photography. After attending Santa Caterina da Siena College, and receiving his masters degree in photography at the Riccardo Bauer Institute, both in Milan, Galano published his first book THE PAST IN THE PRESENT (Art-Studio) at the age of twenty. From 1989 to 1990 he studied in the UK and worked as a correspondent for the Japanese magazine *London Diary*. In 1992, Galano was commissioned by the Lombardy regional government to create a series of portraits of leading Italian figures in the worlds of art, culture, and business. Galano has been living in New York City since 1995, working as a correspondent for major Italian magazines, and in 1998 was awarded a fellowship in photography by the John Simon Guggenheim Memorial Foundation for the support of SIDEWALK STORIES.

More of Salvo Galano's work can be seen on his commercial website, **www.salvogalano.com.**

SIDEWALK STORIES
Photographs by Salvo Galano

Photographs and texts © 2001 Salvo Galano
Introduction © 2001 Jeff Bridges
Afterword © 2001 Patrick Markee

Published in the United States by powerHouse Books,
a division of powerHouse Cultural Entertainment, Inc.
180 Varick Street, Suite 1302, New York, NY 10014-4606
telephone 212 604 9074, fax 212 366 5247
e-mail: stories@powerHouseBooks.com
website: www.powerHouseBooks.com

First edition, 2001

Hardcover ISBN 1-57687-118-5

Library of Congress Cataloging-in-Publication Data:

Galano, Salvo.
 Sidewalk Stories / photographs by Salvo Galano.
 p. cm.
 ISBN 1-57687-118-5
 1. Homeless persons—New york (State)—New York—Portraits. 2. Portrait
 Photography—New York (State)—New York. 3. Galano, Salvo. I Title.

 TR681 H63 G35 2001
 779'.9305569—dc21

 2001036806

Special thanks to The Buhl Foundation for their generous support
Tritone separations, printing, and binding Artegrafica, Verona
Design by Yuko Uchikawa

A complete catalog of powerHouse Books and Limited Editions
is available upon request; please call, write, or come to our website.

10 9 8 7 6 5 4 3 2 1

Printed and bound in Italy